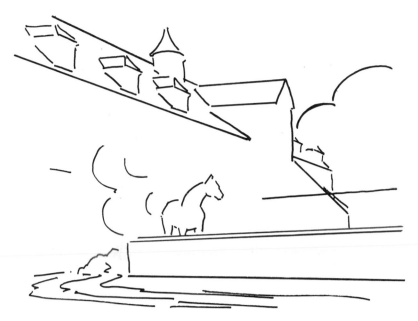

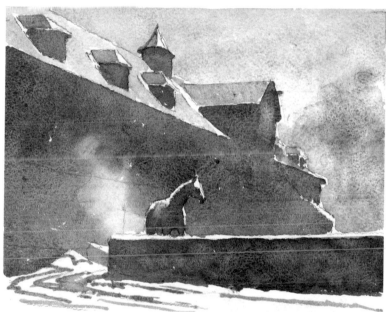

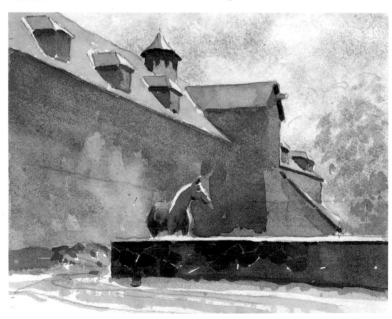

COLOR, COMPOSITION, AND

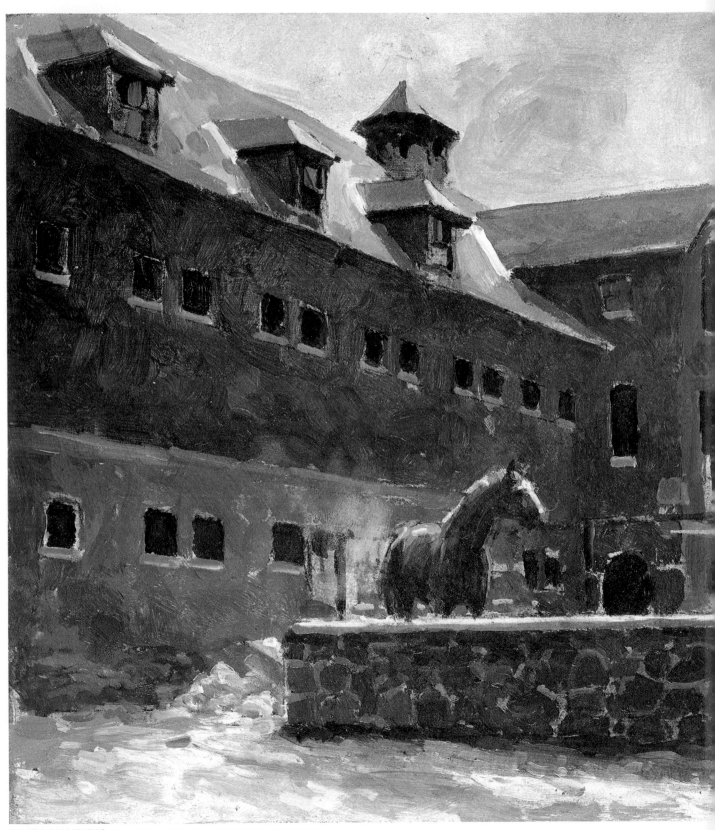

HAMILTON FARM, *oil on Masonite, 8″ × 10″ (20.32 × 25.40cm).*

LIGHT IN THE LANDSCAPE

S. ALLYN SCHAEFFER

**WATSON-GUPTILL
PUBLICATIONS**
New York

Frontispiece art:
Top: *Compositional sketch for HAMILTON FARM*
middle: *Value study for HAMILTON FARM*
bottom: *Color study for HAMILTON FARM*

First published 1986 in New York by Watson-Guptill Publications,
a division of Billboard Publications, Inc.,
1515 Broadway, New York, N.Y. 10036

Library of Congress Cataloging in Publication Data

Schaeffer, S. Allyn, 1935-
 Color, composition, and light in the landscape.

 Includes index.
 1. Landscape painting—Technique. I. Title.
ND1342.S3198 1986 751.45′436 86-15717
ISBN 0-8230-0704-9

Distributed in the United Kingdom by Phaidon Press Ltd., Littlegate
House, St. Ebbe's St., Oxford

Manufactured in Japan

First Printing, 1986
1 2 3 4 5 6 7 8 9 / 91 90 89 88 87 86

*To my wife, whose support and encouragement
have made painting possible.*

Contents

Introduction

Color, composition, and light are three of the building blocks a landscape painting must possess in order to be successful. No amount of good drawing or painting technique will compensate for the lack of sensitivity to these elements. The use of color offers unlimited possibilities in painting. Work with it to develop your own natural color sense. Composition in painting is simply the organization of all its elements; the parts must all work in relation to each other. Light has the ability to transform a landscape by highlighting it at one point and hiding it in shadow at another. In essence, the effects of light are basically the subject of all paintings. The following is a brief discussion on how these important painting elements are explored in this book.

COLOR

Color is obviously a primary consideration for the landscape painter. Nature abounds with color, from the brilliance of fall foliage and spring flowers to the ethereal softness of morning light. Painters often talk about color temperature, colors that are either warm or cool. Yellows, oranges, and reds are thought of as warm; greens and blues are considered cool. Thus, a yellow-green color would be warm, but a purple that leans toward blue would be cool. Neutrals such as grays or browns are interesting because they can be mixed to create both warm and cool tones. When you paint a landscape, it is important to think about the balance of warm and cool color. If your landscape is predominantly cool, warm accents will add a sense of variety and vitality to the scene.

Color also creates a sense of space in a landscape painting. That means that some colors convey a feeling of distance while others convey closeness. Thus, foregrounds and near objects tend to be darker and brighter than backgrounds and distance objects, which tend to be paler and lighter. Keep in mind, however, that painters often exaggerate these differences in order to make their paintings appear spatially dramatic. Throughout this book, you'll find paintings that are accompanied by color keys, or swatches of color mixtures, that make up certain designated parts of the painting. These color keys show you what combination of colors creates the specific colors found in the paintings of this book.

The value of a color also adds to the sense of space in a painting. For example, darker values tend to come forward, whereas paler values tend to recede. Throughout this book, all value determinations will be made with the aid of a simple value scale (see page 15). This value scale indicates seven gradations of value, from absolute white to absolute black and the various gradations between these two extremes. This scale is easy to make and very handy when it comes to determining the value in a particular section of your painting. In this book, we've made it easy for you by including these value indicators with many of the paintings. This system gives you both the value of a certain area of a painting and the exact combination of colors that were used to create a particular color.

COMPOSITION

Composing a landscape painting is perhaps the foremost problem faced by a landscape artist. This is true because it is the design of a picture that gives it impact and forms its underlying structure.

The first question that a painter should ask himself or herself is "what is there in this scene that interests me?" because the emotional response should always come first. Composition is simply picking and choosing from among all the elements of a scene.

Approaches to composition are as varied as painting styles. But often artists conform to three or four basic procedures for determining composition. When working outdoors, an artist generally goes through a process of selecting and arranging what he or she considers nonessential. In many cases, the subject suggests the composition, which only evolves fully during the process of painting. Studio work is a different matter. Working from sketches, photos, or other reference, the artist conceives the composition and adjusts the subject to fit that concept. In this case, the design comes first and the sketches and studies of the subject material are altered to fit the composition.

A third approach is to take the outdoor sketch and make a formal study of its patterns in the studio. Working away from the subject and its demands makes it much easier to readjust the material to fit the formal design.

Throughout this book, compositional approaches to a particular setting or subject are explored. In most of the lessons, compositional diagrams and sketches are provided to show the intended design of a finished painting. These are an attempt by the artist to describe the compositional forces in effect as the painting progressed. In other cases, the reference photograph determines the composition of the completed painting.

LIGHT

The constantly changing effects of light on the landscape present a major problem for landscape painters. And as outdoor work is the only effective way to study landscape painting, it is essential to be able to control these effects.

One way to handle the effects of light is to know your subject well. If you have spent time in a particular site studying a certain light effect—such as late afternoon light in high summer—it would be wise to start painting a few hours earlier to establish all the main forms of the painting. Once the main forms have been sketched in, you will be able to concentrate on any of the desired light effects once they are at their peak. Returning to the subject at the same time on a number of consecutive days is another way to control the problem of changing light.

When light changes suddenly (or sometimes even subtly), it's time to start another sketch or to wait for another day to complete your painting. One thing to avoid is constantly changing the painting as the light changes. Once you gain a little familiarity with the location, it is possible to anticipate exactly how the light will move through the site. When you determine this, you'll know how the light should look in your painting.

The time of day is an important factor when painting a landscape. For example, midday is a particularly hard time of day to paint because the sun is directly overhead; each form in the landscape is engulfed in its own shadow, a characteristic that makes the distinction between shadow and light difficult to achieve. On the other hand, since the light of early morning or late afternoon comes from an angle low in the sky, it casts longer shadows that move across the landscape, thereby creating more interesting shadow patterns than those found at midday. Also, this early morning late afternoon light has the potential for a dramatic effect because objects in this lighting situation appear in silhouette, often with a ring of glowing light encircling them.

Light direction is also important, and it's often a good idea to sketch out this direction before you start to paint. Included in this book are samples of light direction sketches for various paintings. Obviously, light direction is primarily something you must observe firsthand, but you also can exert some control over light direction in your paintings. You can do this by walking around the site until you feel satisfied that you know the light falls in that spot. Then, once you know where you want your light to come from, you can change the light direction in your painting accordingly.

Landscape artists need to be aware of the color of light. Light just isn't unadulterated white; it changes dramatically at different times of the day and under different weather conditions. For example, dawn is celebrated for its rosy glow; dusk is often an intensely warm yellow; and on frigid winter days light can be blue-tinged. So before you mix your colors, determine what the color of the light actually is—and your paintings will invariably be enhanced.

Value and color study for BRIDGE (p. 10)

Introduction

Shadows, too, are not simply blotches of gray and black. They contain varying degrees of light as well as color. Also, shadows reflect the surrounding colors that they fall on; thus a shadow on blue water may look like a darker shade of blue.

WORKING FROM PHOTOGRAPHS

Photographs can be a great help to the artist who is able to interpret them to advantage. If you are going to use photographs in your paintings, you'll first need to acquire some skill in photography. This prerequisite is necessary because reference shots are often required to determine the composition of the finished painting.

Many of the paintings in this book were painted either partially or completely in the studio from photographs or other reference material. To be able to correctly interpret this material, the artist must have made some study of landscape painting outdoors, or, at the very least, be a keen observer of nature.

It is important to keep in mind that we don't see as the camera does; and many photographs are full of distortion of one kind or another. So it is helpful to think of the camera as another sketching tool. For example, a rough color sketch can be used to record the mood of a subject, and the camera can be used to record detail. When a subject is backlit, it's a good idea to take two exposures: one to record the sky and one for the foreground. Photographs are also useful for close-up details.

If you are working from photographs taken by a photographer other than yourself, the problem of interpretation may be even more difficult. Although photographers and painters are both artists, they generally don't approach a subject in the same way. Often, we attempt things in a photograph we would criticize in a painting.

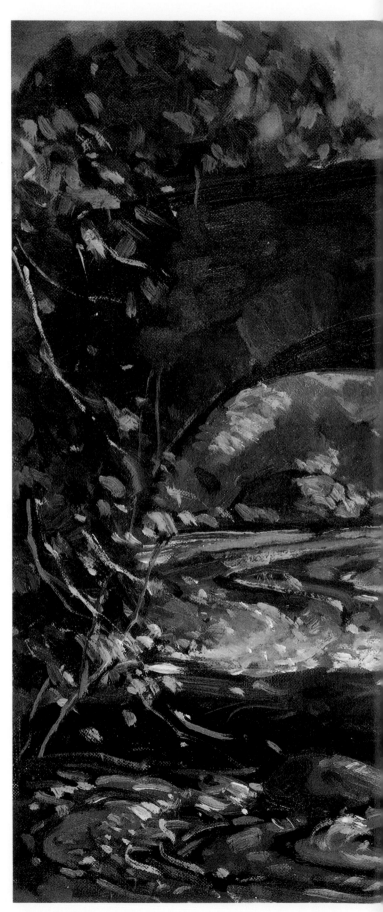

BRIDGE, *oil on panel,*
16″ × 20″ (40.64 × 25.40cm).

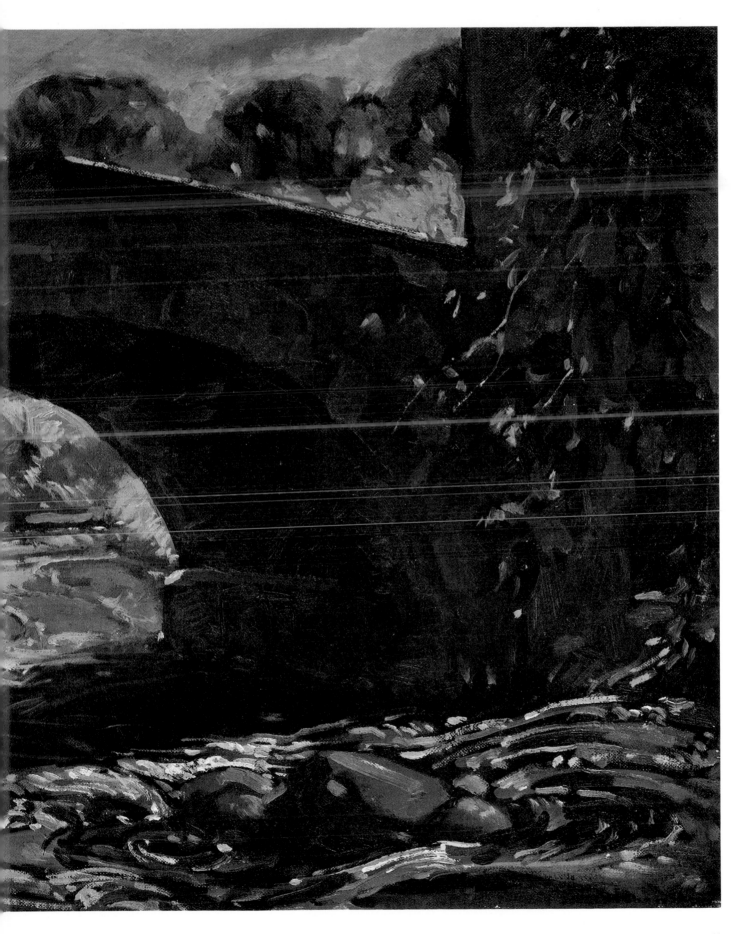

Choosing one element to dictate the composition

The study of trees should be carried out when the branches are at least partially bared. Autumn, winter, or early spring are the best. These are the times when the skeleton is bared and the framework is understandable. Once you are familiar with the branching and character of the bared tree, painting the masses of seasonal foliage becomes much easier.

In this painting I chose a nearby tree to contrast its rough texture with the snow. The fall leaves that cling to the young trees add color to the winter landscape.

Compositionally, the main tree is centered directly on the vertical canvas, but its trunk is broken by leaves and shadows, elements that keep it from dividing the painting starkly in half. The other trees form a triangle shape that recedes over the hill.

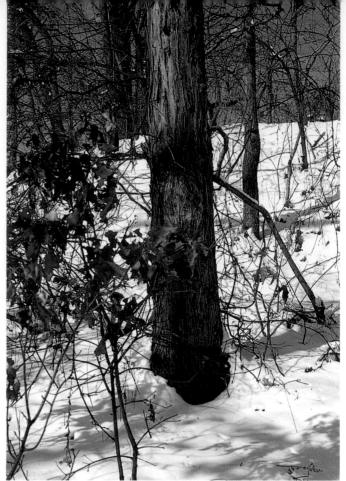

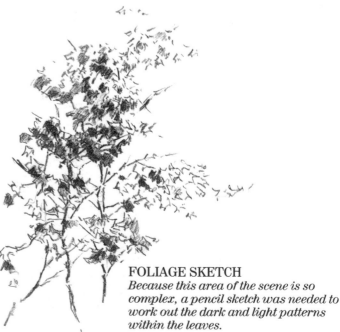

PHOTO REFERENCE
Winter Trees was essentially composed from this photograph, where I was very conscious of the shadow patterns on the snow as part of the composition. The central arrangement of the main tree was done intentionally. Although this smack-in-the-center composition is not usually seen, I felt that the foliage on one side offsets the severity of cutting the painting in two.

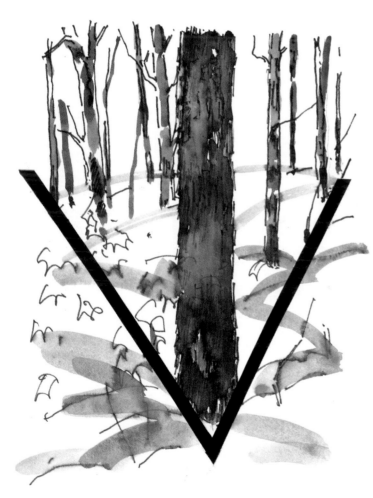

COMPOSITION SKETCH
This sketch illustrates the V-shaped composition of the painting.

FOLIAGE SKETCH
Because this area of the scene is so complex, a pencil sketch was needed to work out the dark and light patterns within the leaves.

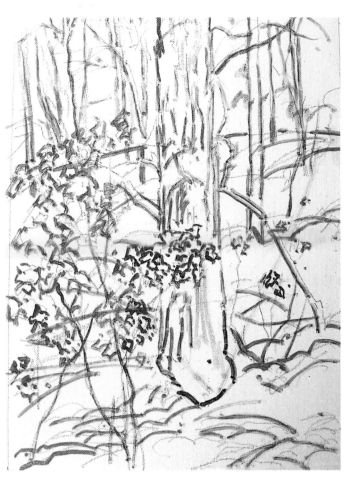

STEP ONE
The charcoal drawing is first reinforced with thinned color because it is too fragile by itself to successfully serve as a foundation for the painting. Unless it is a very complicated subject, I don't normally like to use a fixative to preserve the initial charcoal drawing. Even when fixed, charcoal tends to dirty the color painted over it.

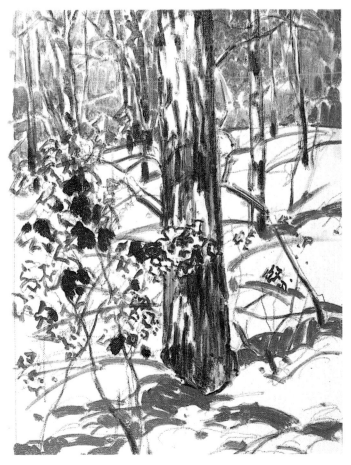

STEP TWO
The darks are established with thinned color, leaving the white of the canvas for the lights of the painting. The directional lines of the composition and the patterns of dark and light become more obvious at this stage. My concern was to establish proper value relationships over the entire painting, to judge one area in relation to another. Once these values are established, adjustments in color are easier to make.

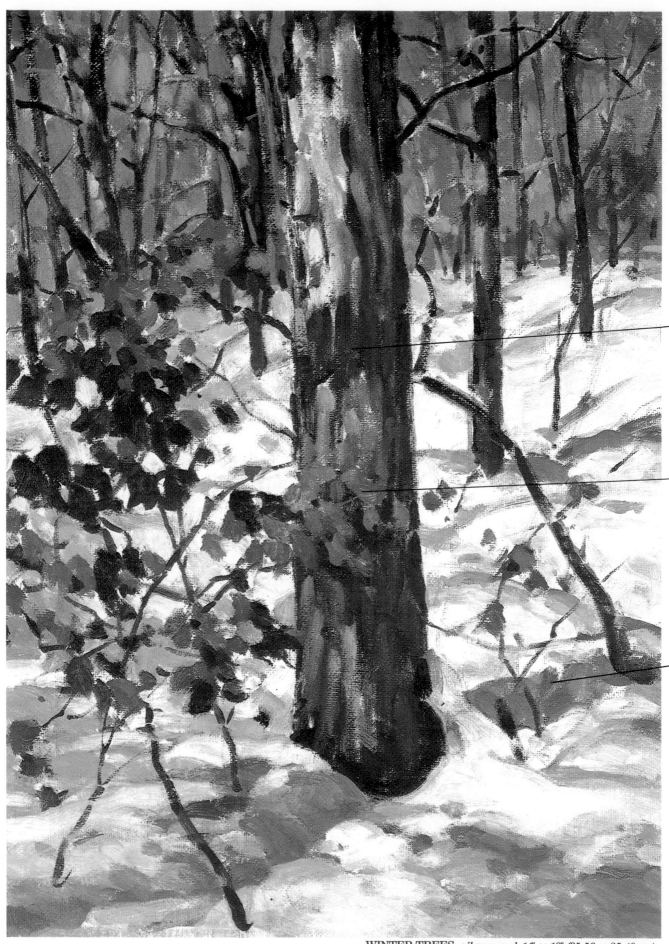

WINTER TREES, *oil on panel, 14″ × 10″ (35.56 × 25.40 cm).*

FINISHED PAINTING

Using heavier color, I worked back into the darks, building up color and value. The sky and snow were painted over the trees and foliage. If these areas had been painted first and the trees second, the painting process would have been delayed considerably and almost certainly have been less effective. This is true because, in order to judge the sky or snow areas, the trees and foliage need to be established beforehand. The color and value of the snow can only be right when seen in relation to the trees.

burnt umber cobalt blue

6

cadmium red light cadmium orange

3 1

cobalt blue mars violet

4

white

COLOR KEYS

Throughout this book, many of the finished paintings and details of finished paintings are accompanied by color keys, or color swatches, indicating the specific color mixtures that produced a certain color found in the painting. Next to these mixtures, you will also see a value number, ranging from 1, the very lightest, to 7, the darkest value.

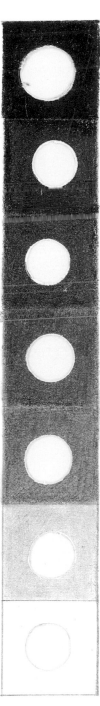

VALUE SCALE

One of the biggest problems a painter has to solve is that of judging value as it relates to color. Very few students are able to do this naturally; more often it has to be learned.

To aid in this learning process, I suggest making and using a value scale and finder like the one you see here. It will be used throughout the book. You can make one from a sheet of white single-ply bristol board marked off in 1-inch squares. Each square is filled in with a different degree of Wolf's carbon pencils. DDD, the darkest black value, is value 7; BB is value 6; B is value 5; HB is value 4; HH is value 3; HHH is value 2. The last square is the white of the paper, or value 1. Use firm pressure to produce an even tone inside each square.

To turn this value scale into a value finder, cut a hole out of the center of each square. These holes should be about 1/3" in diameter. They may be cut in any manner, but a compass with a sharpened divider point cuts a very clean hole. To finish the finder and prolong its life, spray it with a protective plastic coating.

To use the finder to access the relative value of a color in question, simply look through it to match the value in the painting. It can also be used to compare one value in relation to another. As you read through this book, note that all value determinations are based on this value scale.

Using the bull's-eye light effect

This painting is about the effects of light. Its composition is merely a foil to set off the sparkle of water on a dark winter stream. To capture this effect, paint in the trees rather loosely and impressionistically, as if you were looking only at the water. If you look past the foreground areas to the background, the background will come forward and become more important than it needs to be. Then it is no longer a background. So don't try to paint three or four pictures in one painting. Concentrate on only one element or area that is the primary reason for the painting. Remember, no painting ever failed because it lacked detail; on the contrary, bad paintings are full of nonessential detail that hide the subject.

Compositionally, this painting forms a zigzag line that weaves throughout the painting. This format is a very basic compositional device. Learn to search out these compositional forces in other paintings.

The placement of the lights in this painting is affected by the composition, which is essentially a bull's-eye design with the light area as the center. As a general rule, it's not a good idea to place a strong light or color at the edge of a painting; this would tend to take the viewer's attention right out of the picture.

The dominant color mixture used in varying values throughout this painting is cobalt blue and light red. Mixed with white, these two colors make up the shadows and halftones in the snow. The same mixture without the white or with less white was used for the distant trees. This one simple mixture offered many subtle variations.

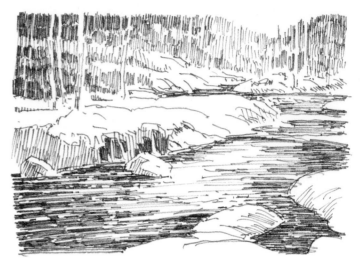

VALUE SKETCH
This sketch shows that the lights are kept to the central area of the painting. Thus, the painting is basically light in the center and gets darker at the edges. This type of value arrangement has the effect of automatically focusing the viewer's attention. Note the unequal balance of one-third light to two-thirds dark, which makes this painting more interesting than if the values had been more evenly balanced.

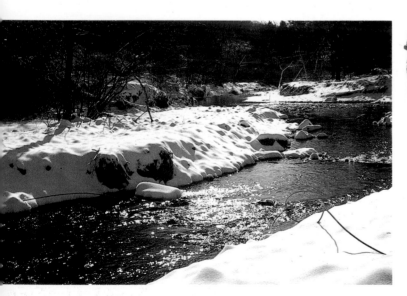

PHOTO REFERENCE
Although this photograph has its limitations as a reference source, it manages to capture the dancing light on the water—which is just what I needed it for.

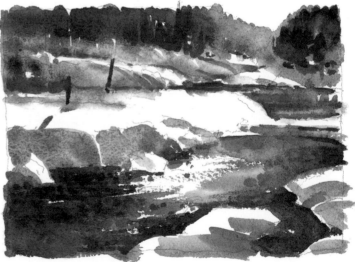

COMPOSITION SKETCH
Partway through this painting, I felt that the severity of the foreground snowbank was not working within the painting as a whole. This drawing enabled me to visualize a curved bank, one that brings the eye of the viewer back into the painting rather than out of it.

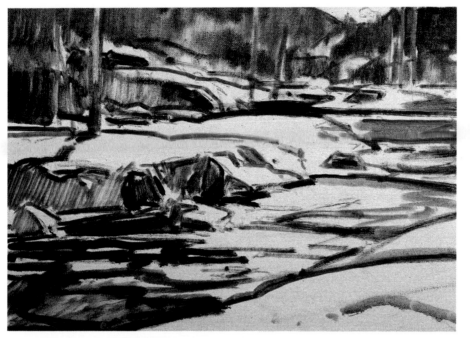

STEP ONE

I began this painting by locating the basic lines of the composition and concentrating on the big shapes. The preliminary drawing was made with charcoal and then redrawn with thinned color. A soft vine charcoal allows more freedom at this stage than any other drawing material. To change a line you merely have to wipe off the old one with a dry cloth. Redrawing with thinned color (mixed with mineral spirits) replaces the fragile charcoal drawing with a more permanent line.

The color of the preliminary drawing is generally the same as the color found later in the finished painting. This makes the drawing underneath compatible with the overpainting and quickly establishes the overall range of color.

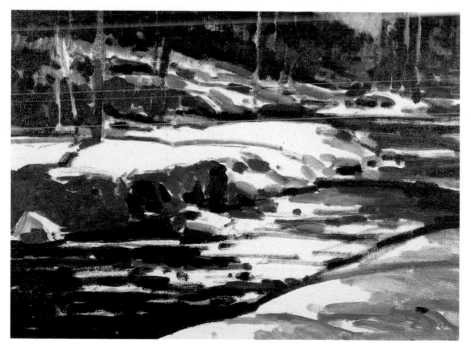

STEP TWO

When the placement of all the essential big shapes was satisfactory, the dark values were brushed in, leaving the white of the canvas in the light areas. At this stage the general color and value over the whole painting has been established.

Since the application of thinned color dries very quickly, you can start working with heavier color immediately. (I use color just as it comes from the tube with little or no medium.) Then, starting again with the darks, I make any adjustments to their color and value that are necessary. Remember, everything you do in these first stages looks dark in relation to the white canvas, so make sure your darks are dark enough. Many of the light areas are still the bare canvas at this point. Don't be in too much of a hurry to paint the lights. You'll find if you get the darks established, the lights will take care of themselves.

Using the bull's-eye light effect

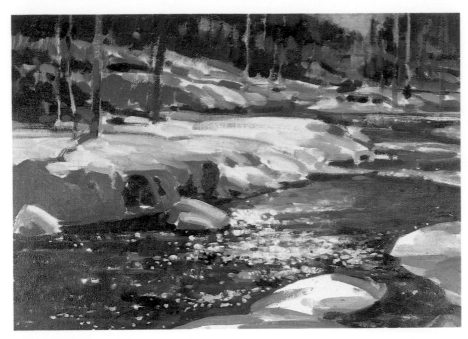

mars violet 7 ultramarine blue

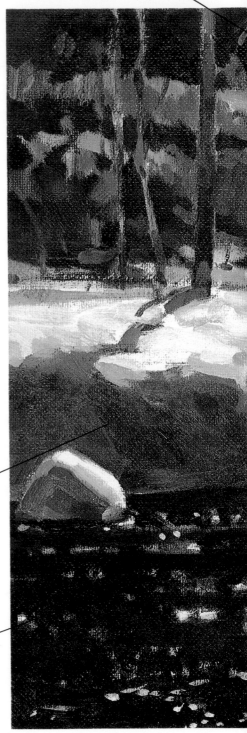

STEP THREE
At this stage I decided to change the foreground snowbank, whose uninteresting straight edge had been bothering me for a while. In order to alter the composition in this area, I made a small drawing to work out the possibilities. I also repainted it on a piece of clear acetate and placed it over the foreground area of the painting. This technique allowed me to visualize the change without working on the painting. Then, satisfied with the effect of a more irregular snowbank, I redrew the foreground on the painting with a brush and thinned color.

With the darks well established, the middle and light values of the snow could be put in to further develop the sparkling light effect on the water. The snow was painted with long fluid strokes that follow the contour of the land, and the sparkling water was made up of many overlapping short strokes or spots of color. Using both warm and cool colors of the same light value helps to create an optical vibration or shimmering effect of light on water.

6

cobalt blue light red

FINISHED PAINTING
Without establishing too much detail, reds were added in the distant trees and their shapes were defined. The foreground snow was painted much like the already existing snowbank; and the light effect on the water was strengthened by darkening the surrounding water. In a situation like this, there is the temptation to make the lights lighter, but what is really necessary here is to make the darks darker.

7

phthalo green alizarin crimson

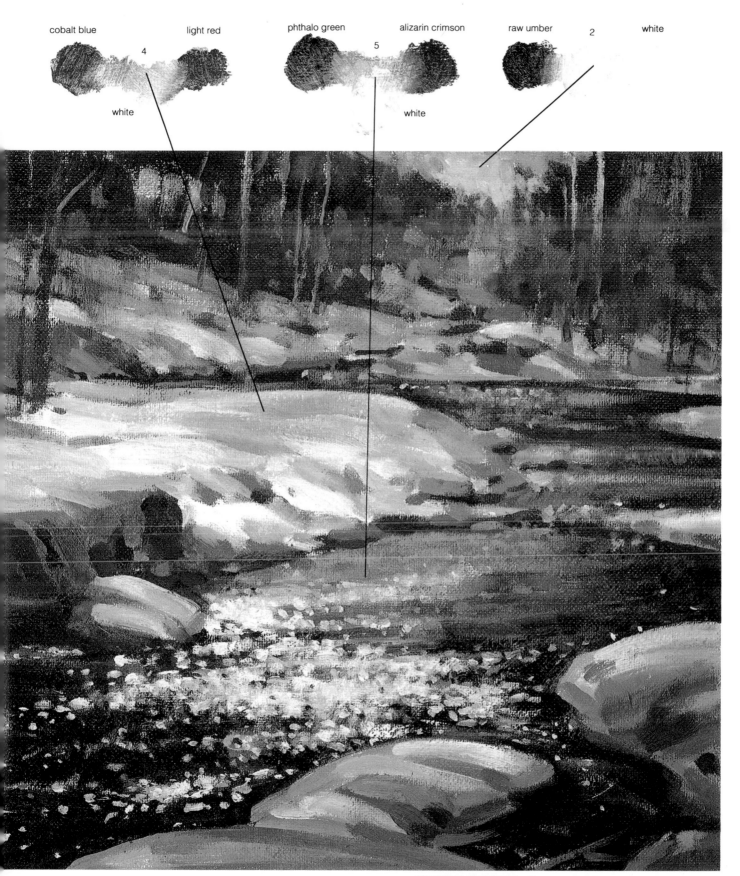

cobalt blue light red phthalo green alizarin crimson raw umber 2 white

4

white 5 white

WINTER STREAM, *oil on panel, 14″ × 10″ (35.56 × 25.40 cm).*

Balancing lights and darks

It is very important not to lose track of the reason for a particular painting, which is the one thing that made you want to paint it in the first place. It is very easy to become involved with unessential elements and in doing so lose the impact of your initial concept.

Study this painting to see how different it is when compared to the light-filled effects of the previous painting. Both are winter streams, both were painted on clear, sunny days, yet they are quite different in feeling. This difference is easier to understand when you realize the stream is not the subject in either painting. The previous painting focuses on the sparkling light on the water and every other element in the painting is worked in relation to that light. This painting is more concerned with the lacy patterns of snow and shadow that describe the snowy bank.

Compositionally, this painting is a balance of opposing lines: the leaning trees and their shadows, the direction of the stream opposed to the shadows on the snowbank, and the sky pattern. All of these forces offer a slightly different version of the zigzag compositional line.

This painting reveals a proportion of approximately one-third light to two-thirds dark. In general, equal balance between the patterns of dark and light lacks interest. Divide a composition in thirds with light, middle, and dark values, and you will have a full range of value but a very uninteresting design. If you change the proportions to create an unequal balance, see how much more exciting the design becomes.

Oftentimes during the painting process, you'll realize that the initial impact of the painting has been lost. But typically all that has really been lost are the correct balance of dark and light values. Reestablishing the darks is often all that's necessary to correct the situation.

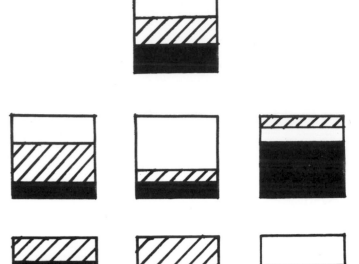

VALUE DISTRIBUTIONS
An unequal balance of dark and light is usually more interesting than an equal distribution. When values are equal, the picture tends to have a static quality. Note the interesting patterns that can be made with an uneven distribution. This is especially effective when creating a certain mood or atmosphere is your intent.

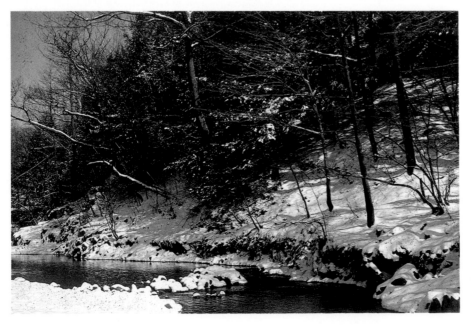

PHOTO REFERENCE
This picture of the scene illuminates my main concern—the lacy shadow patterns that the trees cast over the snowy bank.

WATERCOLOR SKETCH
This sketch shows the basic value structure of the painting in simplified form. Remember, it's very helpful for the painter to know the value break-down of the scene being painted.

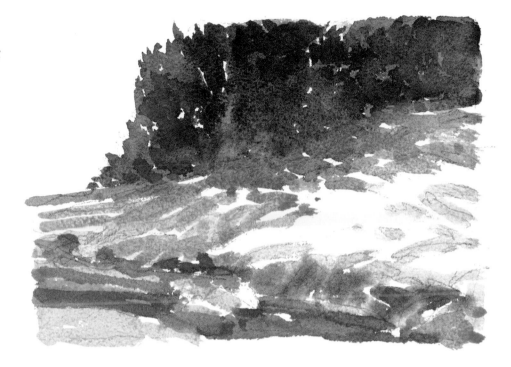

FINISHED PAINTING
To finish this painting I worked back over most areas, adjusting color and value and adding detail, such as delicate branches. In general, the heavier applications of paint were kept to the light areas.

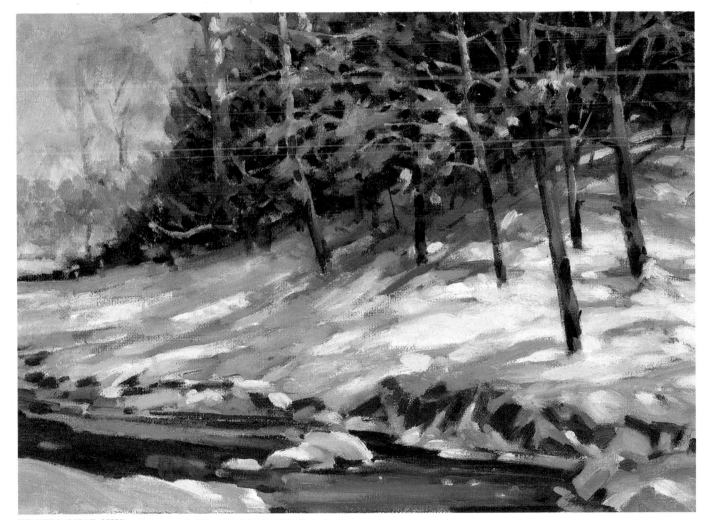

WINTER SHADOWS, *oil on panel, 14″ × 10″ (35.56 × 25.40 cm).*

STEP ONE
Because this painting consists of simple shapes, the drawing was done with thinned color and not with the usual charcoal. Note that only the big shapes are indicated at this point.

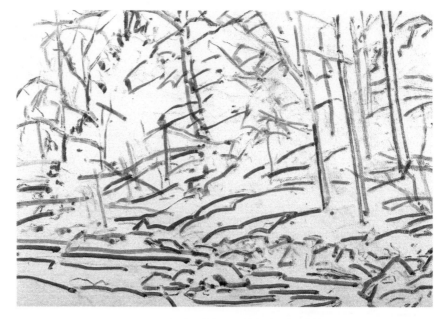

STEP TWO
The darks of the trees and the stream were worked in with thinned color and the general pattern of the shadows was established, leaving the bare canvas for any light areas.

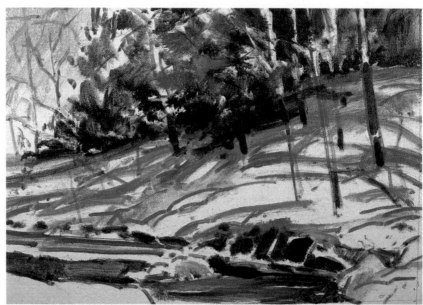

STEP THREE
Using heavier paint, I began to work back into the underpainting of thinned color to build up the darks of the massed trees and their shadows. Note that the individual trees are not defined in this dark area. The paint is darkest where the treeline meets the snow (phthalo green and light red); in the deep snow shadow, it changes to cobalt blue and light red. There is no need for a sharp division between the snow and the trees. A change in color is enough; the value remains the same. White was added to the shadows on the snow as they come forward, still leaving the bare canvas for most of the lights.

At this stage I repainted the sky, adjusting it in value to the trees. I also began to develop the shadow patterns. And in areas that were undefined, I redrew with more detail.

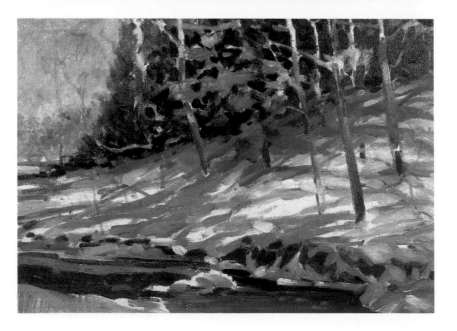

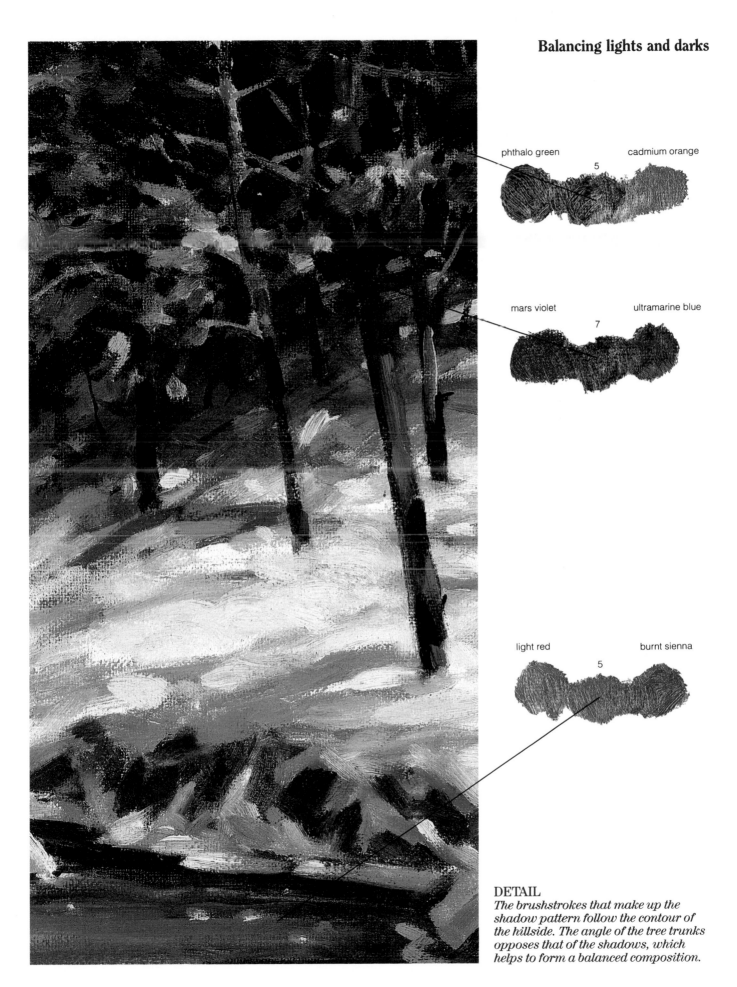

phthalo green cadmium orange

5

mars violet ultramarine blue

7

light red burnt sienna

5

DETAIL

The brushstrokes that make up the shadow pattern follow the contour of the hillside. The angle of the tree trunks opposes that of the shadows, which helps to form a balanced composition.

23

Working from an unusual perspective

The excitement created by this unusual viewpoint of a sycamore in autumn makes it an exciting painting as well. A balanced composition was achieved here by centering the main trunk and arranging the maze of twisting branches into an overall abstract pattern. A careful drawing of the branches and their shadows keeps all the detail in the foreground. The color of the distant landscape seen through the skeleton of the bare tree is reduced to simple abstract spots of color.

There are only two planes in this composition: the foreground branches set against a backdrop of color that only suggests the distant landscape.

A preliminary drawing in carbon pencil was made to work out the complicated branching of the tree. I worked in both line and value in this drawing to better visualize the design. The cast shadows the branches produce are very important in portraying the form of these twisting shapes. To better understand the complexity of a tangle of branches and simplify their drawing, think of each branch as a tapering tube going in one direction or another. Always try to reduce the subject to its simplest form.

The actual painting was done in pastel on canvas that had been toned in a varied pattern of warm browns and reds. I often work in pastel because its working methods and directness of application are similar to painting in oil.

I began the painting with a drawing executed in a dark color that was compatible with the overall color scheme of the painting. For a dark-toned painting such as this, don't draw in a light color; a strong drawing will have a great deal to do with producing a strong painting.

On the toned canvas I was able to establish the dark and light values of the tree at the very beginning. Spots of color were put down in a broad general way and worked over the entire painting at once.

While working, I try to judge each color and value in relation to the rest of the painting. For example, as I brushed in the distant foliage, I judged its color and value in relation to the main tree. Knowing that the strongest darks and lights appeared in the foreground tree makes it much easier to paint the middle value of the distant foliage. If you were to concentrate only on the distant foliage without comparing it in value to the darkest dark and lightest light of the foreground tree, you would probably judge its value wrong. Because of its brilliant color, the common mistake would be to paint the distant fall foliage too light, which would cause you to lose its contrast to the strong light on the tree.

FINISHED PAINTING
The unusual perspective on this subject is what makes this painting exciting.

24

TREE TOP, *pastel on canvas, 14″ × 18″ (35.56 × 45.72 cm). Collection of Doug Turner.*

BACKGROUND STUDY
*Because this painting consists of only
two planes—subject and background—
the background is meant to suggest a
fall environment through the means of
color.*

PENCIL SKETCH
A pencil study of the tangled network of branches provided an opportunity to understand the complicated forms of the tree.

PERSPECTIVE SKETCH
The foreshortened effect of branches projecting toward you is difficult to draw. If you think of them as tapering cylinders, they become easier to draw than when thinking of them as branches, with all their complicated and confusing qualities.

Highlighting one element in a landscape

Very often one element of a subject will be exciting but will lack the other necessary ingredients in order to make it work as a painting. The foreground may be empty, the background confusing, or some other part will be wrong.

In this painting a pretty grove of trees framed a very uninteresting apartment complex. So I decided to work on the trees anyway, keeping in mind that I would have to plan a solution for the background later.

Back in the studio, I made a number of black-and-white compositional sketches based on the trees. Because the foreground area was quite complex, I chose the simplest sketch; this would give more depth to the painting.

This painting deals with strong contrasts. The light of the distant trees would mean very little without the darks. Try not to get carried away with the vivid fall colors. If everything is painted in with brilliant reds and oranges, the effect will be lost. Colors are much more muted at this time of the year than you would first think. Try to see the green in a red or yellow tree.

To keep the depth of view I wanted, I thought of the composition as a stage set divided into separate planes. Thinking of a landscape as a series of planes helps to sort out complicated subjects, such as massed trees, and to place everything in its correct plane.

PLACING THE PLANES OF A COMPOSITION
This sketch shows the various planes found in the picture. If you divide up the composition in this way, it will help you to place the elements in each plane more accurately.

ALTERNATIVE SKETCHES

These sketches were done to try to compose the background area of the painting. In the bottom sketch, the background is much more complicated. I decided that the top sketch made a better composition because the background is simpler, and it doesn't fight for attention with the complexity of the foreground. The strength of the foreground trees is exaggerated here so that everything in the picture is not equally important.

Highlighting one element in a landscape

STEP ONE

As I started to work back into the painting, new elements of the landscape were established in broad, general terms; these were painted right over or through the foreground trees where necessary. To a great extent, the foreground area was kept much as it had been originally. As the painting progressed, I continually refined the distant landscape in relation to the foreground.

STEP TWO

Some changes were necessary in the foreground trees. They needed to be opened up somewhat to allow for the new distant elements. While I was working on the trees, I brushed in broad areas of color behind them. Because I had decided to add to the composition, I painted out with white the original sketch. When this dried, I drew in a new composition and began to lay in the green and orange tones of the middleground and background.

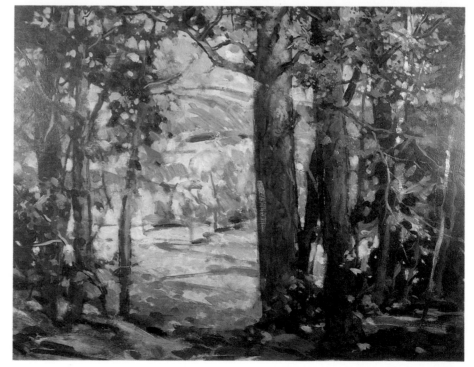

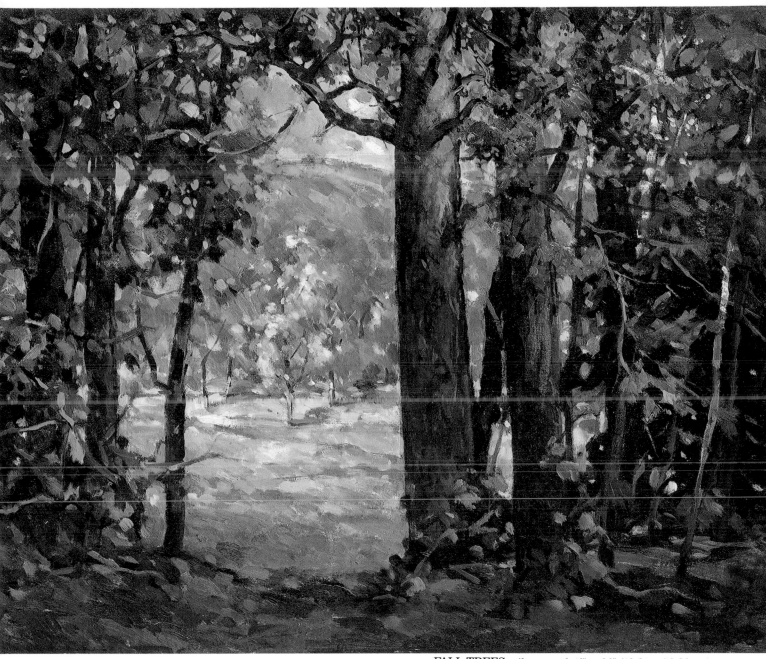

FALL TREES, *oil on panel, 16" × 20' (40.64 × 50.80 cm).*

FINISHED PAINTING

In the final stages, the painting had become almost wholly imaginary. In order to keep the painting working as a whole, foreground patterns were adjusted in relation to the background. Note how the shape of the mountains of the background repeats the shape of the foreground shadow.

Capturing rapidly changing sky patterns

This type of subject, which is more than 50 percent sky, requires a different approach than more static subjects. Because of the fast-moving aspect of the clouds and the constantly changing shadows over this landscape, a prolonged painting at the subject would have been all but impossible.

To begin to capture sky patterns such as these, try making small oil sketches no larger than 8″ × 10″ (20.3 × 25.4 cm). I use a 16″ × 20″ (40.6 × 50.8 cm) canvas board divided into quarters and do a number of quick studies as the sky changes. Don't spend more than 15 or 20 minutes capturing the fleeting effects, and don't be overly concerned with technique. These sketches will be worthwhile for their truth, not their technique.

I also recommend using a camera to augment these sketches. Photographs can be most helpful back in the studio when you are developing the painting. The sketches can also become references for future paintings needing sky interest.

PHOTO REFERENCE
Since cloud patterns change every 10 minutes or so, photographs are an ideal way to record the rapidly changing effects of light.

PERSPECTIVE SKETCH
A knowledge of perspective will allow you some freedom when you are arranging the direction of lines or shapes in a composition. The design of these shapes can be adapted to the needs of the composition without abusing the integrity of the form or distorting it. As a general rule, all lines converge towards the horizon, even those of the clouds. If the horizon is hidden by a mountain or some other form, the lines of the receding sky will continue to the true horizon even though it is out of sight. The arching dome of the sky should also be shown by a change in value and color. In this case, it is darker and stronger at the point overhead, lighter and grayed at the horizon.

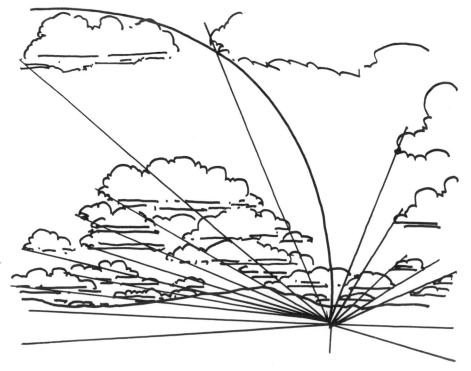

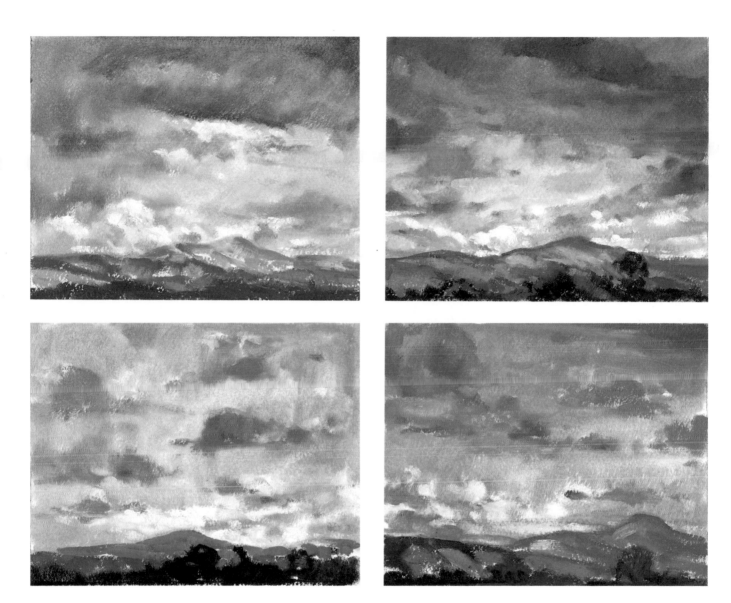

COLOR SKETCHES

These color sketches were made very quickly on location; and the final painting was composed later in the studio. Sky changes are so rapid that it's almost impossible to do a prolonged finished painting at the site.

STEP ONE

Working from my sketches and photographs, I began to draw directly on the bare canvas with a small bristle brush dipped in thinned color. Because of the simple shapes involved, I felt it unnecessary to sketch in the scene with charcoal.

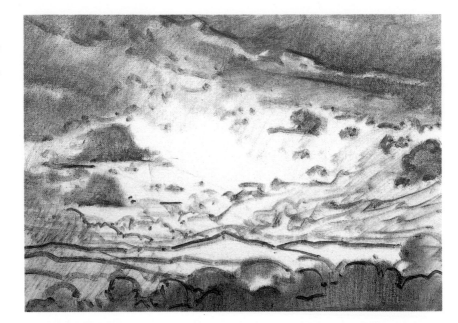

STEP TWO

After the basic cloud shapes had been established, I broadly brushed in the approximate color and value of the dark clouds and the foreground trees, closing in the edges of the painting and leaving the bare canvas for the lights.

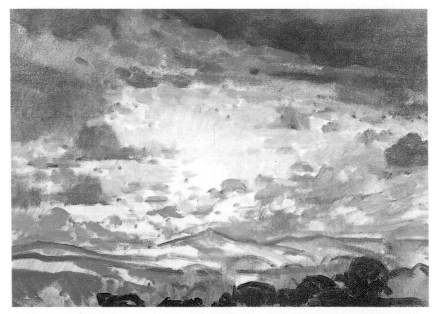

STEP THREE

I painted back into the sky with heavier color, adjusting the cloud shapes as I went along. At this stage, I am still mostly concerned with the darks.

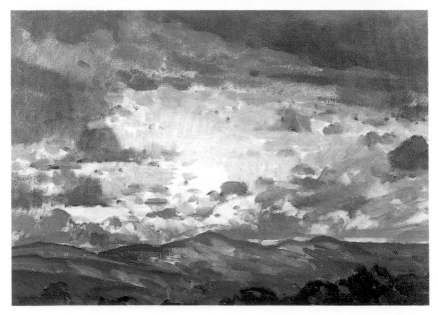

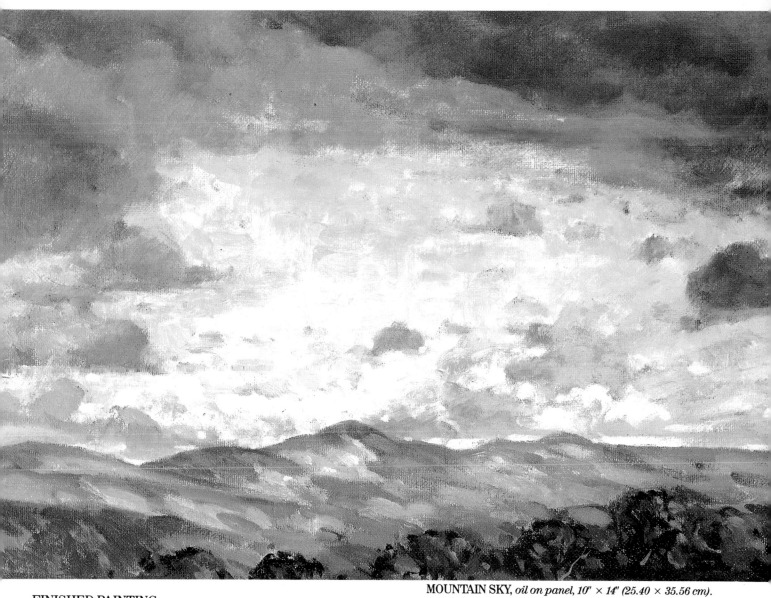

MOUNTAIN SKY, *oil on panel, 10" × 14" (25.40 × 35.56 cm).*

FINISHED PAINTING
The sky was finished later working wet-into-wet over its whole surface to soften some edges. The dark foreground was defined and the mountain repainted against the sky.

Controlling the composition

This wide-angled view of rolling farmland leading back to distant mountains offers an involved pattern of opposing lines or planes, all of which can be controlled in composition. When confronted with such a complex subject, you should feel free to twist and bend these lines to suit the needs of the painting.

As you prepare your composition, carefully consider the placement of buildings and trees, elements that show the scale of a painting and add to the illusion of depth. Try not to get tied into one aspect of your subject too quickly; make sure you are aware of all the possibilities. Take a little extra time to walk over an area before you start to paint. Five or six artists all working from more or less the same location will undoubtedly come up with as many individual compositions.

Working from watercolor sketches, I made other sketches in the studio, and finally made two paintings of the subject. The first painting combines the two sketches for a complete long view of the scene. The second takes a closer view and emphasizes the importance of one of the farm buildings.

A major problem that can develop during the course of a painting is the loss of the darks or the contrast that had originally held the work together and made it interesting. So even though your painting may have many color changes, it will lack the original contrasts and everything becomes one value. When this happens, reestablishing the darks will bring everything back into place. Don't be afraid to make the darks strong enough right at the beginning. Remember, they will look very dark in relation to the white canvas. Keep the darks colorful; don't be put off if they seem to create too much contrast. The worst that can happen is the painting may become a little overly dramatic.

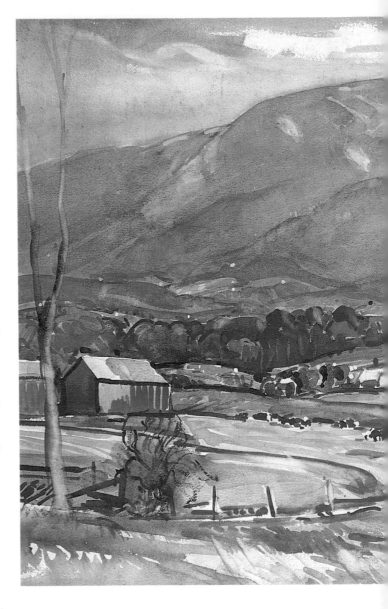

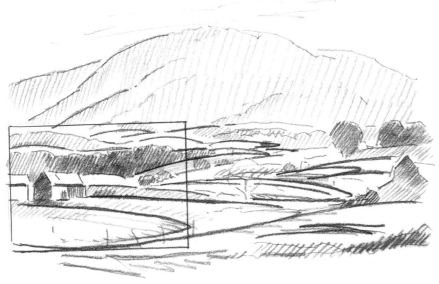

PENCIL SKETCH
This drawing shows an overall view of the subject with the main compositional lines worked out. The rectangular inset shows one aspect of the composition used in the painting. There are many other compositions within this format.

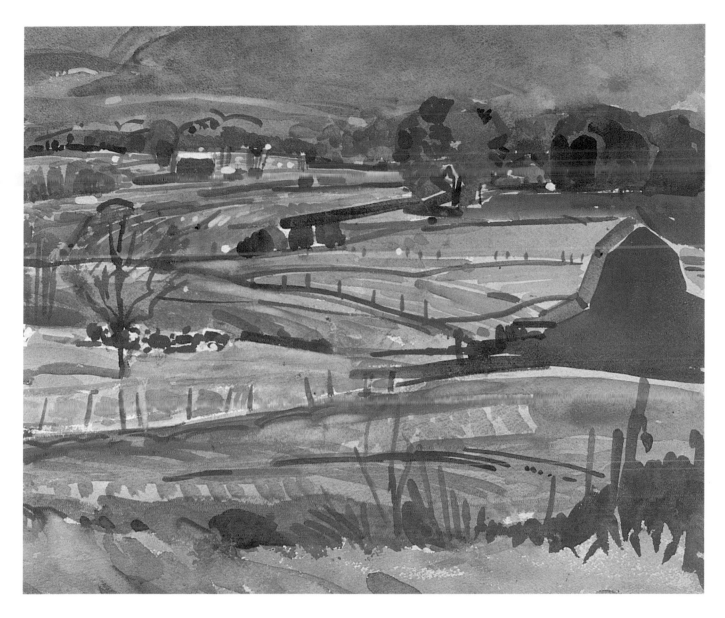

WATERCOLOR SKETCHES

With a wide panoramic view such as this one, you have to either zero in on a subject or paint the whole thing. These are the basic options you have when presented with a landscape scene. In the overall view, the mountain is the primary subject, and the farm buildings are secondary; in the closer, more intimate view, the placement of the buildings becomes more important than the total landscape.

STEP ONE
After a charcoal drawing was made to place the composition and its elements, I redrew the main lines with thinned color. I generally use the full range of color for this initial drawing that I plan to use in the finished painting. This helps to establish a range of color or mood at the very onset of the painting.

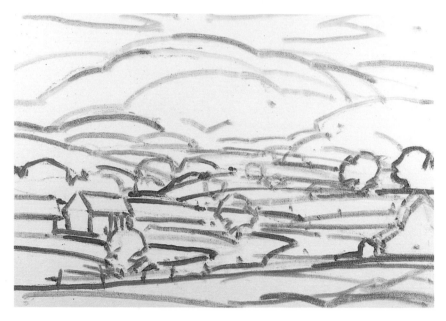

STEP TWO
The thinned color dried very quickly, which allowed me to work back over the whole painting. At this stage I want to cover the white canvas as quickly as possible, establishing color and, even more important, a pattern of dark and light values. The lights were left as bare canvas at this point; they shouldn't be painted in too quickly. If you wait until the darks are established, lights will take care of themselves.

STEP THREE
At this stage, I began to use heavier color with a fully loaded brush, reestablishing the darks and making any adjustment in color and value necessary.

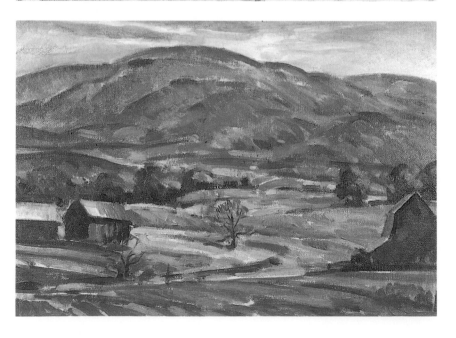

mars violet cadmium red light

4

cadmium orange

phthalo yellow
green cadmium orange

6

cobalt blue light red

3

white

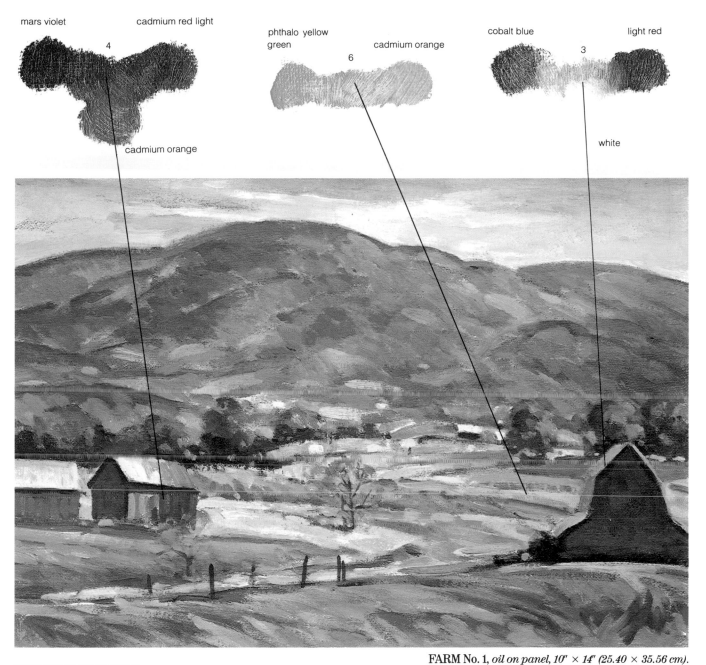

FARM No. 1, *oil on panel, 10″ × 14″ (25.40 × 35.56 cm).*

FINISHED PAINTING
With short strokes made with a loaded brush, I worked back into the large areas of the mountain and foreground fields to add modeling. Final touches, such as details and color and value refinements of the buildings and trees, were also made.

STEP ONE
An initial charcoal sketch was made to place the composition, and redrawn with thinned color. Then, using more thinned color, the dark areas of the painting were brushed in.

STEP TWO
At this stage, the distant dark areas of the mountain were worked back over with heavier color.

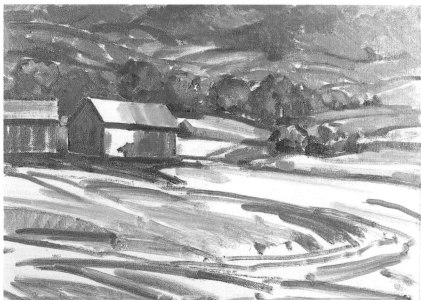

STEP THREE
With heavier, more opaque pigment, the barns were developed in the foreground.

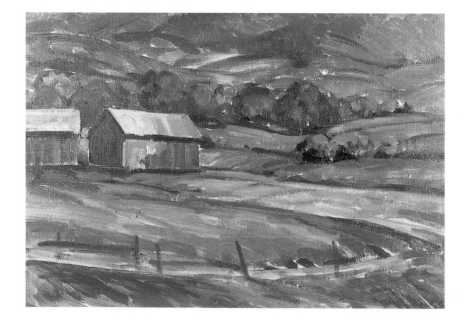

permanent green light alizarin crimson

6

ultramarine blue

permanent green
light 5 yellow ochre

FARM No. 2, *oil on panel, 10" × 14" (25.40 × 35.56 cm).*

cadmium orange yellow ochre

white

FINISHED PAINTING
At this stage, I was concerned with making shapes more definite and with defining the edges of things. To refine details, the entire painting was worked back over. The tree shapes and grass patterns and edges were defined more clearly.

Selecting the best subject

Two versions were painted of this subject. The first features an old willow tree with a tangle of branches at its base. The second, a much wider view, offers an entirely different subject, where the tree and house give way in importance to the winding stream. The tree, which is so important in the first painting, becomes just one of many elements in the second.

I can't stress enough how important it is to walk through the painting site before choosing a subject. Take a little extra time to become familiar with the area. Don't just set up your easel at the first comfortable spot you find and then look for something to paint. You must be willing to arrange the subject before you. If it suits your composition, bend the stream or road, or move a house or tree and position it where you want in your painting.

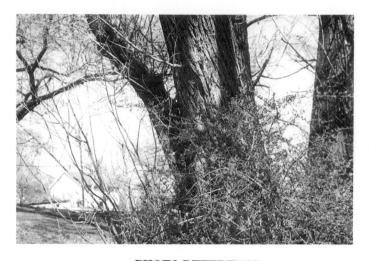

PHOTO REFERENCE
It's important to spend a little time establishing a good composition. Just by moving around on the site, the possibilities will become apparent. This close-up photo is basically a portrait of the tree and its gnarled underbrush.

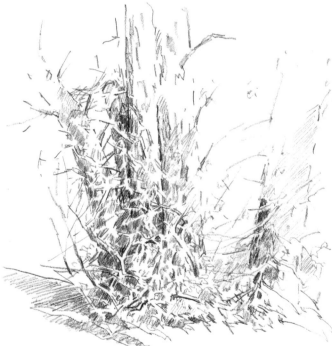

PENCIL SKETCH
This drawing was done to help me to see the dark and light patterns found in the tangle of branches and foliage at the base of the trees. In both the drawing and the painting, the branches are defined by establishing the dark, negative spaces behind them.

PEN SKETCH
In this sketch I worked out the composition before starting to paint, just to make sure everything in the scene was going to fit together in a pleasing fashion.

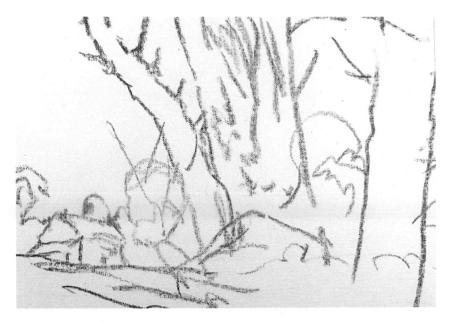

STEP ONE
I redrew the initial charcoal drawing with thinned color and established the dark patterns in the trees.

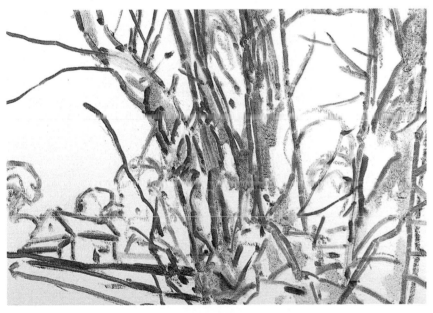

STEP TWO
Working back over the thin underpainting, I painted the sky in with heavier color. I kept it somewhat darker so the light branches of the willow would be more important. At this stage, the light areas of the painting are still the bare canvas. In the beginning, I try not to paint the lights too quickly and concentrate more on the darks and middle values.

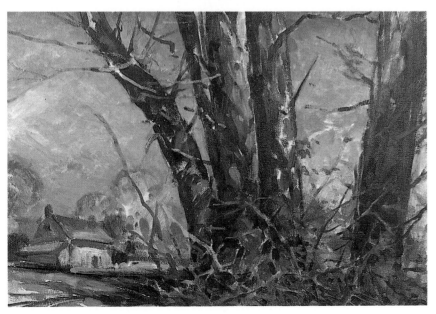

STEP THREE
As the painting progressed, I began to develop the confusing foreground patterns. The tangle of branches at the base of the tree is an area that must be thought out and a design developed. I did this by painting back and forth between the dark interior and the light surface branches. There is an anatomy to this maze of branches and foliage that must be realized for it to look right.

Selecting the best subject

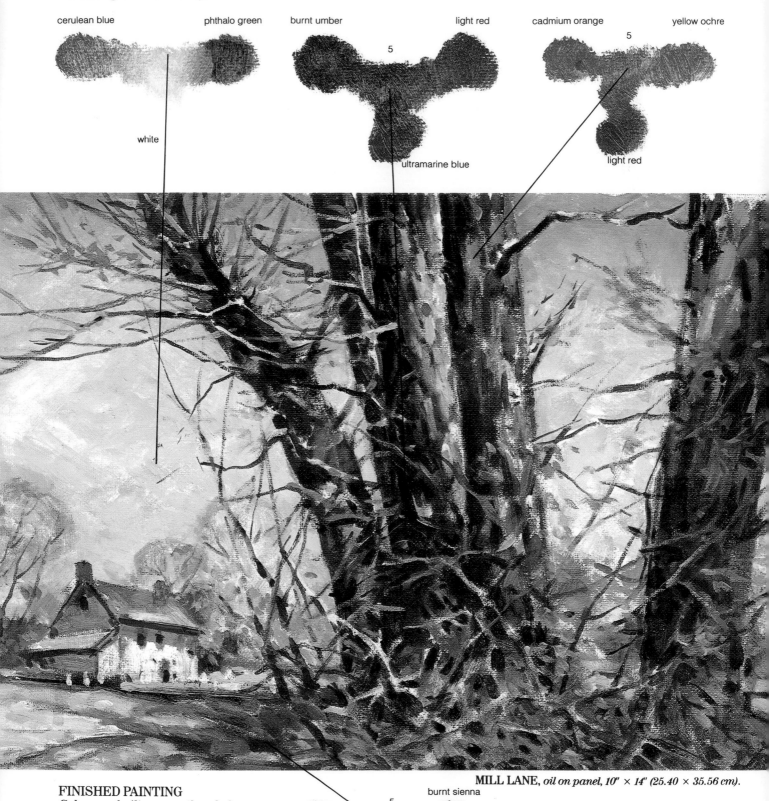

cerulean blue phthalo green burnt umber light red cadmium orange yellow ochre

white

5

ultramarine blue

5

light red

FINISHED PAINTING
Color was built up over the whole painting using short brushstrokes that follow the contour of the forms they are defining.

5

burnt sienna

phthalo green

MILL LANE, *oil on panel, 10″ × 14″ (25.40 × 35.56 cm).*

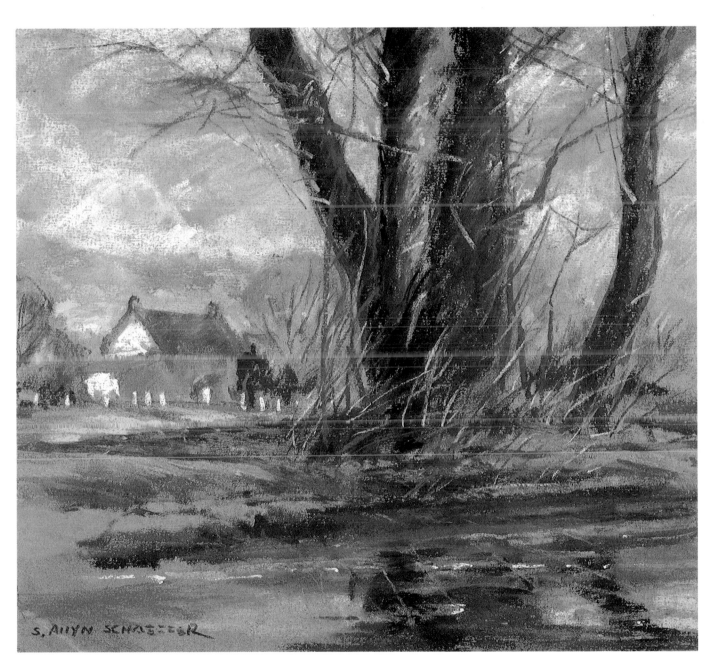

PASTEL SKETCH
This is another view of the same subject, where the reflections in the stream become an important aspect in the picture.

Selecting the best subject

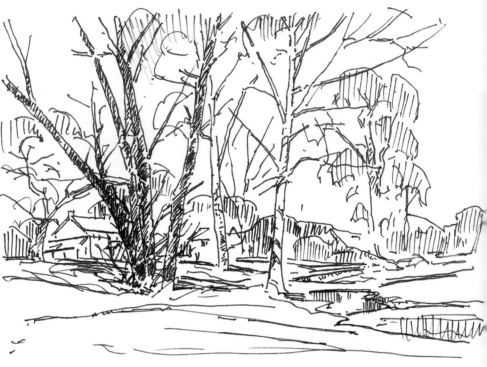

PHOTO REFERENCE
In contrast to the close-up shot, this photo takes in much more of the stream and makes the stream and several of the trees its subject.

PEN SKETCH
In this sketch I worked out the composition before starting to paint, just to make sure everything in the scene was going to fit together in a pleasing fashion.

ESTABLISHING VALUES
The initial drawing, or underpainting, was much the same for this painting as for the first. When it was finished, I proceeded to establish the three main values: the sky, the flat plane of the ground, and the vertical plane of the trees. The sky was painted over the trees, which, because of the strong drawing, remain visible.

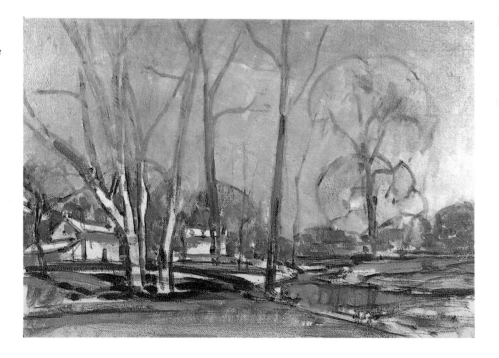

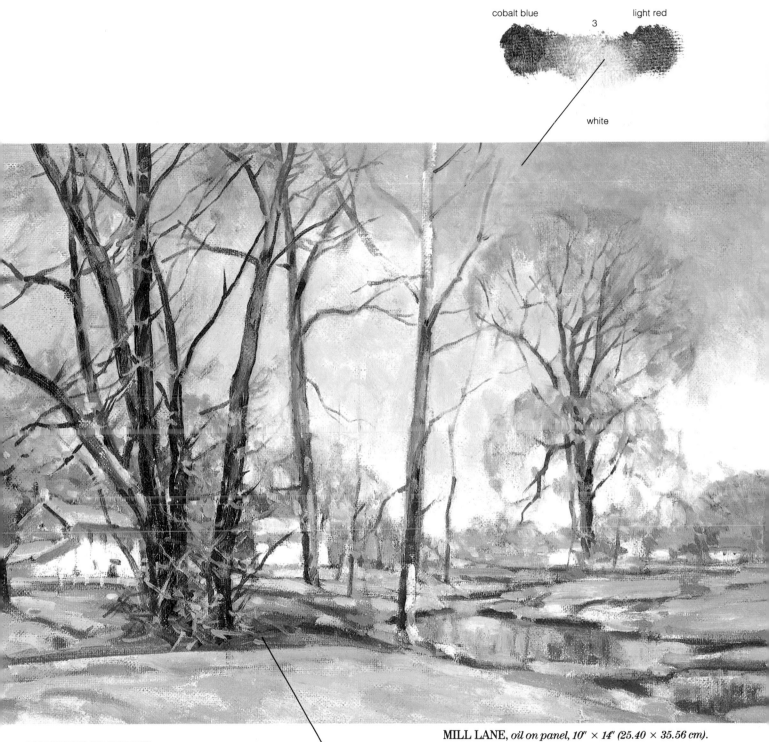

cobalt blue

light red

3

white

MILL LANE, *oil on panel, 10" × 14" (25.40 × 35.56 cm).*

FINISHED PAINTING

Here I added the details: light branches against areas of the sky that hadn't been painted before. These final accents—in trees, small branches, and the leaves—were not considered in the early stages.

light red

5

permanent green light

Inventing the composition

This painting was composed in the studio; I worked directly on the panel from sketches and photographs. Since I was not interested in making an exact portrait of this subject, I changed elements in the scene around it in order to create a stronger composition.

To alter the scene to my liking: the skyline was raised, placing the cathedral-like arch higher and larger against the dark sky; and the modern high-rise buildings were left out. The middle distance, however, was kept much as it appears in the photo, but I emphasized angles and shapes that would strengthen the composition and lead the viewer back to the cathedral.

The light in this painting is a quickly moving effect that changes constantly. Much of the painting is in shadow that is broken only by the light that falls on a few roofs at a time before moving on. To aid the composition, I tried to be selective in arranging where these spots of light fell.

The high vantage point of this painting offers an unusual perspective of the buildings. As the painting progressed, I continued to redraw the buildings' angles and shapes in such a way as to lead the eye all through the painting. The sky was also treated as a compositional device; its complexity of color and shapes reflects and complements the busy hillside that lies below.

PHOTO REFERENCE
These photographs show a wide-angle view of the subject: one focuses on the distant skyline; the other on the foreground buildings. Later, they were combined to form a working composition and then a painting. In this case, I only referred to the photographs at the beginning, but not once the painting got under way.

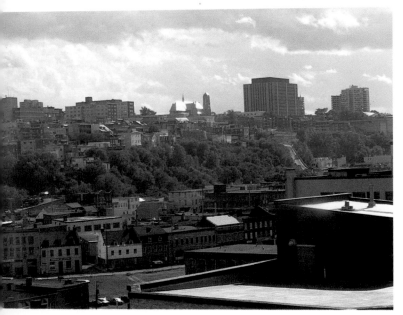

48

STEP ONE

Working on a toned panel, I sketched in a rather detailed drawing in charcoal. Once the composition was worked out, the charcoal was dusted off, leaving a faint image of the drawing. It was then redrawn with thinned color as I continued to refine the design. When the color drawing was dry, a blue-toned wash of thinned color was brushed in over the entire panel to creae a middle value and set the mood for the painting. By toning the panel after the drawing, I was able to cover the white surface quickly and establish values closely related to the painting. Even with the many buildings of different colors, there is always one essential color or tone that will tie them all together.

STEP TWO

Working back over the toned painting, I began to establish the dark and light patterns in large basic shapes that suggested the buildings's shapes more than their details.

FINISHED PAINTING

Next, I painted in the sky almost completely, and adjusted the color and value of the hill in relation to it. I also added color and detail to the foreground buildings and refined the other areas into a unified whole.

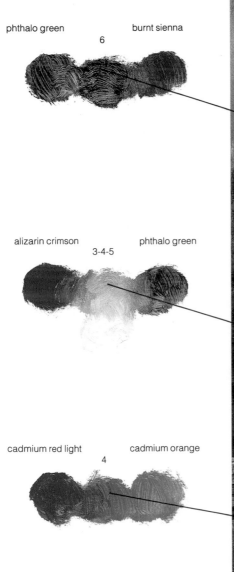

phthalo green burnt sienna

6

alizarin crimson phthalo green

3-4-5

cadmium red light cadmium orange

4

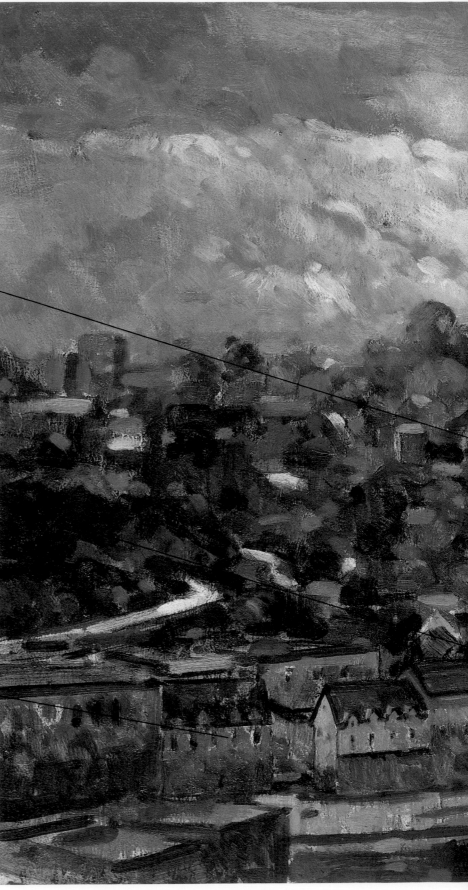

QUEBEC,
oil on panel, 15" × 30"
(38.10 × 76.20 cm).

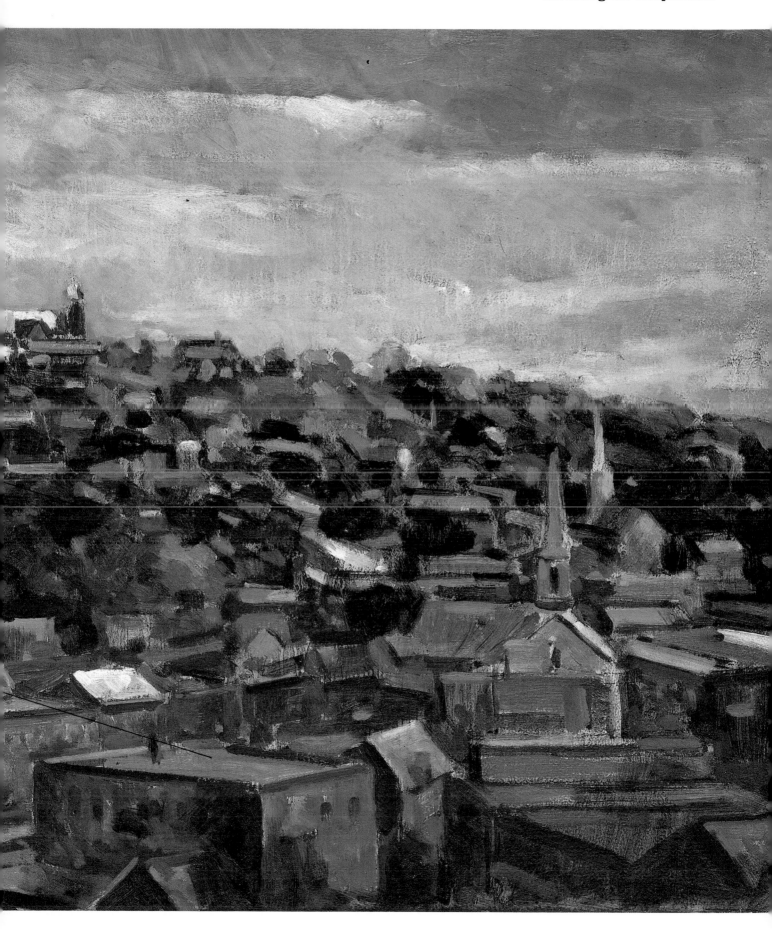

Establishing values on a toned surface

This painting was worked over an old canvas that had been randomly toned with a cool gray color over a warm orange. The original painting was to have been a late fall scene that had barely been started when a couple of rainy weeks held up any outdoor work. When the sky cleared, the subject had changed too much to continue the painting. This is not an uncommon problem for landscape painters, and I often will keep a toned canvas over until the next year or season when I am able to continue.

The reference source for this street scene was an overexposed slide. Often, those seemingly ruined photographs can be useful as subject matter. By only exposing the sky correctly, the foreground became quite dark, which created a more dramatic landscape. For painting purposes, it is wise when photographing into the light to expose one shot to record the sky and another for the foreground or details.

PHOTO REFERENCE
At least for painting purposes, don't think that less than perfect photographs are worthless. Although the foreground is overexposed in this shot, the photo is still very informative in terms of the sky.

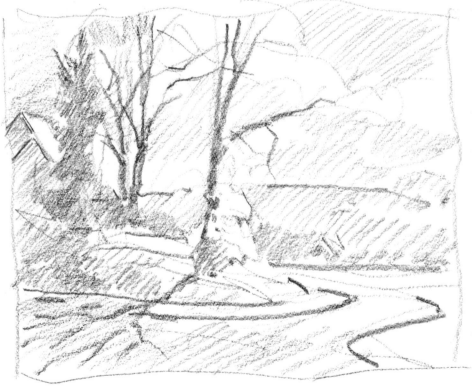

PENCIL SKETCH
Before I begin to actually paint, a black-and-white sketch helps me to visualize the value patterns I will encounter later. In this case, the foreground house and trees all become silhouettes. The only strong light is in the sky, which is again reflected in the winding road.

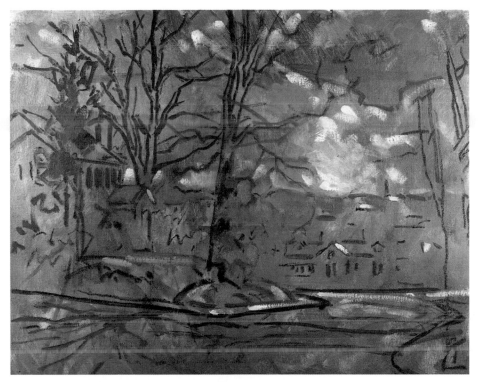

STEP ONE

On a canvas of medium tone, I began painting much as I would on a white surface by establishing the drawing with a dark color or the actual color of the scene. Working on a toned canvas allows me to establish the light values at the very beginning; and when the canvas tone serves as the middle values, I can concentrate on establishing the dark and light patterns.

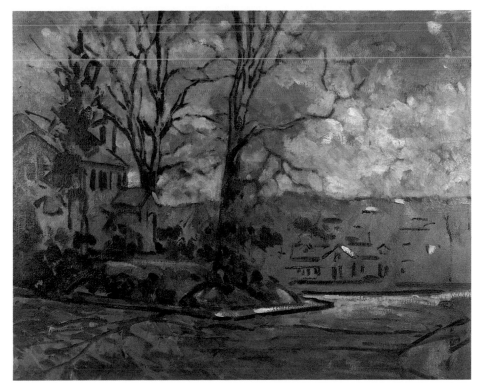

STEP TWO

The sky pattern was arranged to reflect the curving line of the street. The bright light from the sky keeps everything else in this painting silhouetted, except for a small area of central light and the bright colors of the lawn and fall foliage. The sky color infuses all the other colors in this painting, creating a total harmony of tone. Remember, with so much of the painting in shadow, it's important to keep the darks colorful.

Establishing values on a toned surface

STEP THREE
The tree shapes were finished over the already completed sky. Because of the fragile quality of the trees, the sky was painted in first. Then the trees were drawn in simply but not developed in any detail; because the branches are so thin, it would be difficult to paint around them. If the branches had been thicker, I probably would have painted in the sky after the trees. The foreground shadows were also developed at this stage.

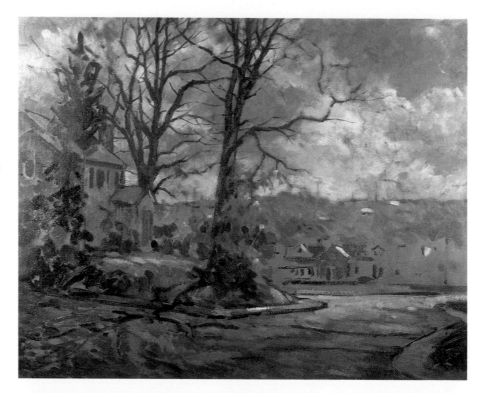

FINISHED PAINTING
In the preceding steps, the tone of the canvas represents the hilly background. In the finishing touches, I developed that distant background area with suggestions of trees and houses.

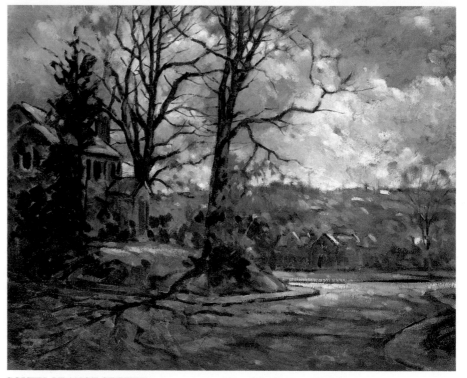

SOUTH ORANGE STREET, *oil on canvas, 16" × 20" (40.64 × 50.80 cm).*

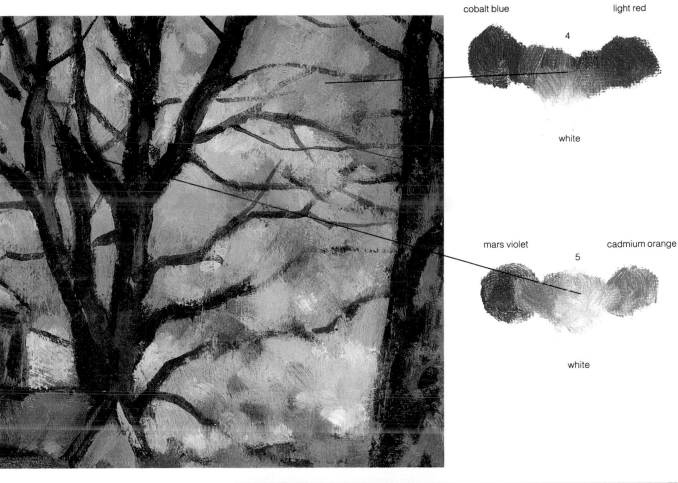

cobalt blue light red

4

white

mars violet cadmium orange

5

white

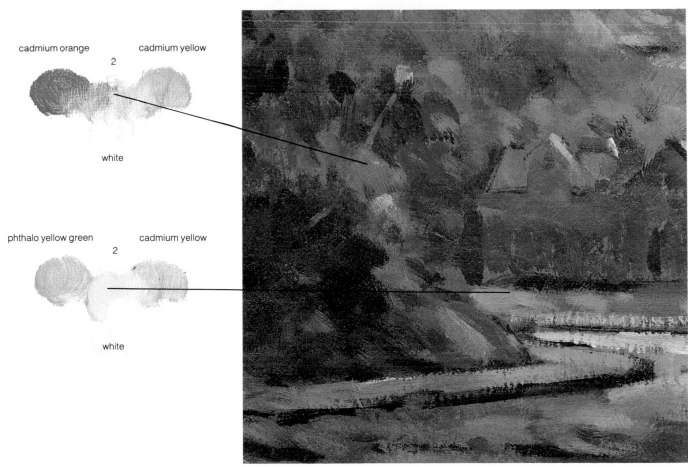

cadmium orange cadmium yellow

2

white

phthalo yellow green cadmium yellow

2

white

Creating drama
with shadow patterns

All too often artists will ignore the shadows in the early stages of a painting to concentrate on what they think are more important objects. By doing so, they risk losing any dramatic effect or feeling of light and shade that the painting might have had.

In this painting the shadows tell the whole story. Everything was arranged to bring the viewer's attention to the strong central light. The resulting bull's-eye design is framed by the dark arch of the overhanging tree. To complete the effect of repeated forms, this arched shape is reflected in the shadowy beach patterns. Subtle changes in color add interest to the beach patterns, which are arranged to lead the eye back into the center of the painting.

PHOTO REFERENCE
This scene had all the earmarks of a painting to me. So, in this case, the composition had already been worked out in the photograph.

PENCIL SKETCH
In order to become familiar with this boat's classic shape, I had to draw it before I painted it. Although this small fishing boat looks simple, it can prove to be a subtle shape to draw. Its sensual curve, if not seen correctly, could call attention to itself.

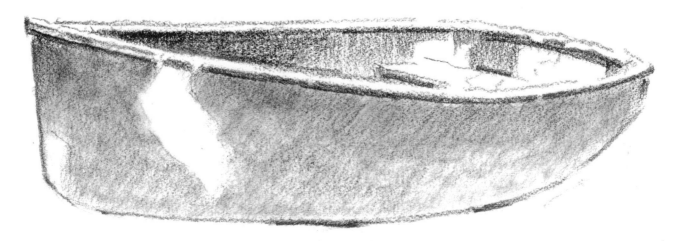

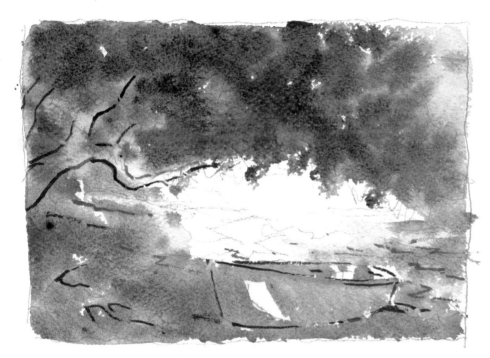

WATERCOLOR SKETCH

I used this sketch to define the patterns of darks and lights. It helped to establish the bull's-eye area of light centered in the middle of the picture, a device that automatically draws the viewer's attention to the central area of the painting.

STEP ONE

I made a strong drawing to establish the main shapes that make up the composition. Note that the forms of the shadows curling over the beach lead you back to the bright area of water.

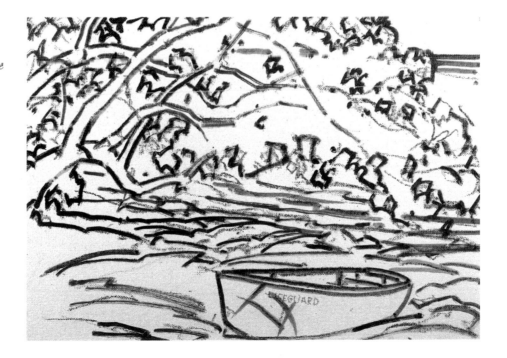

Creating drama with shadow patterns

STEP TWO

To establish the mood of the painting, I needed to get down the main values over the whole painting quickly. I did this by keeping the shapes simple. Also, I had to be careful to paint the darks dark enough. Since at this stage everything looks dark in relation to the white canvas, you will need to exaggerate the dark values in order to get them right. Value is more important at this point than color. Subtleties of color can be achieved later. Work toward the big effect right from the start. Your painting should look good at every stage.

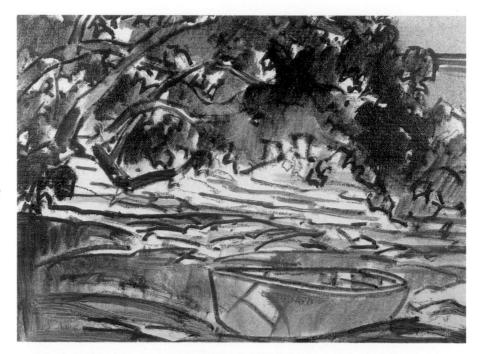

STEP THREE

Once the canvas was covered and everything established, I worked back into the painting with heavier color. At this stage I normally use the color just as it comes from the tube, with little or no painting medium.

Adjustments in value and color are made with big strokes; they are not much more than spots of color placed side by side. I worked from dark to light without becoming involved with detail. The heavy tree is painted as a silhouette, not as leaves, because I am looking for its big shape.

For now, the lights can be left as bare canvas. Concentrate on the darks and middle values, and you'll find that the lights will take care of themselves. Always be careful not to get too light too soon. Although much different in color, the white boat in shadow is almost the same value as the shadow itself. This is because if it's painted too light, the boat will "pop" out of the shadow.

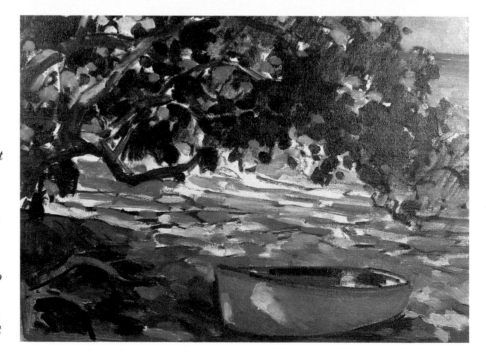

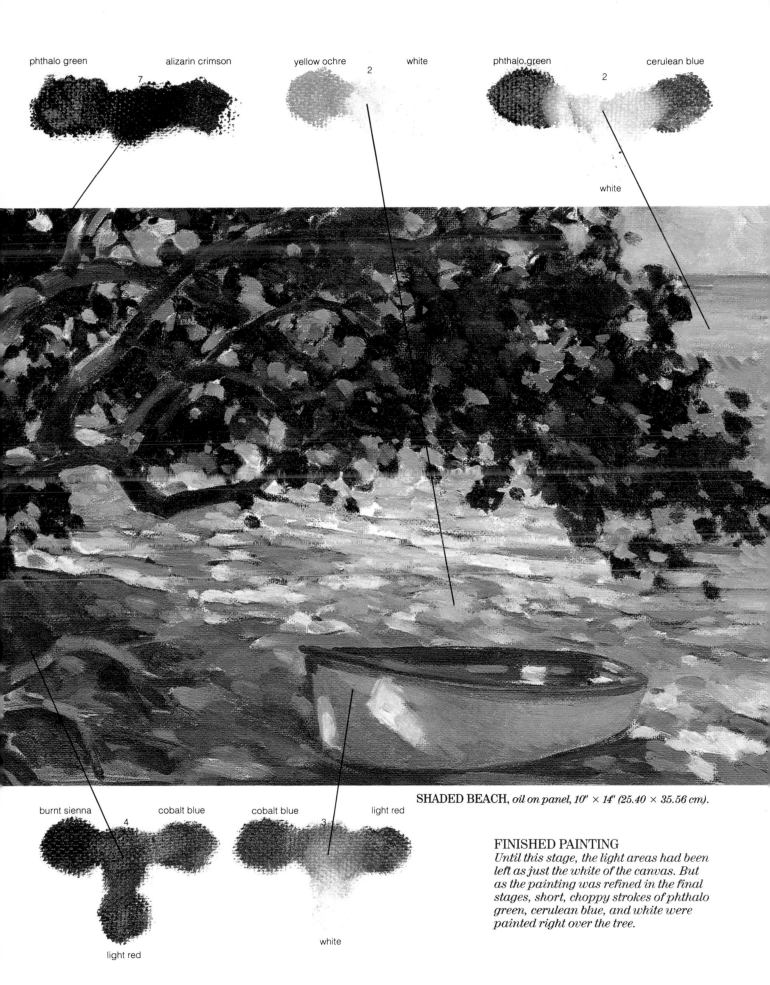

phthalo green alizarin crimson

yellow ochre 2 white

phthalo green cerulean blue
 2

 white

burnt sienna cobalt blue cobalt blue light red
 4 3

 light red white

SHADED BEACH, *oil on panel, 10″ × 14″ (25.40 × 35.56 cm).*

FINISHED PAINTING
Until this stage, the light areas had been left as just the white of the canvas. But as the painting was refined in the final stages, short, choppy strokes of phthalo green, cerulean blue, and white were painted right over the tree.

Trying out new proportions

The preliminary painting for this subject was done on location with a group of artists. The bridge, large trees, and stream provided many possibilities for different compositions, as each person was able to spread out and find his own approach to the subject. Some concentrated on the bridge, while others paid more attention to the stream; all in all, six or seven quite different compositions resulted from the same subject.

After walking through the area reviewing the subject with my class, I chose a vantage point that allowed me to keep the bridge large and also play up the raking light that passed over its rough surface.

As usual, I had brought along a variety of canvases of different sizes and proportions. After jotting down several quick thumbnail sketches, I decided on a square canvas, a format that I feel is not used often enough, especially by artists too concerned with the economy of ready-made frames and standard-sized canvases. If nothing else, working on canvases of different proportions forces you to find different solutions to problems of composition. If you always paint on 16″ × 20″ canvases, you will through familiarity develop formulas for composing the picture area and quite possibly never experience the excitement of solving a new problem.

A word of caution: when painting outdoors, don't over-concentrate on a certain light effect; this will occupy too much of your attention and the painting as a whole may suffer because of it.

FELT-TIP DRAWINGS
These simple line drawings indicate the light and directional patterns of the picture. Note how the composition drawing at lower left is very similar to the design of Trout-Stream *on page 67.*

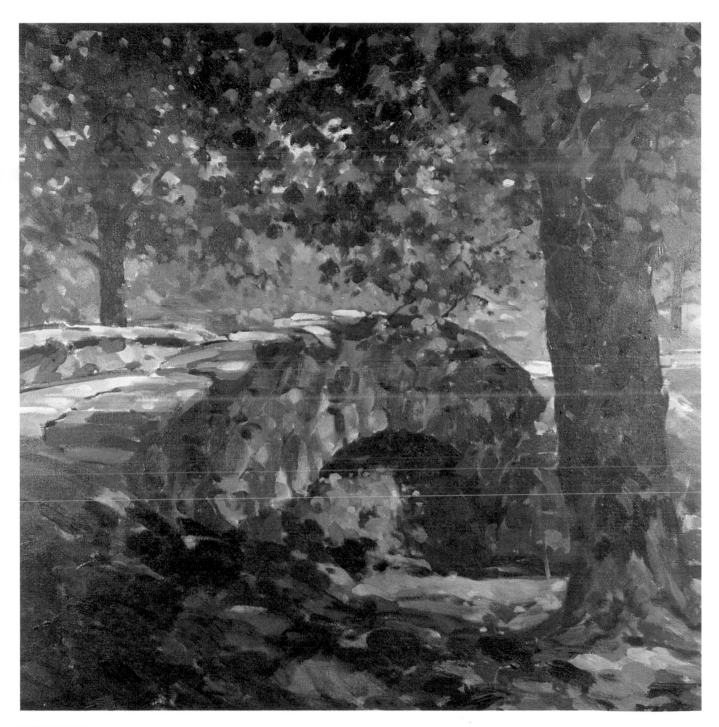

STEP ONE

When reviewing this composition in the studio, I was pleased with the effect of light playing on the rough stone bridge but felt overpowered by the foreground tree. I wanted to keep most of the dark foliage casting their shadows on the bridge; and, at the same time, in order to open up the composition, I needed to remove the uninteresting tree trunk. I also wanted to show more of the distant trees and create a greater feeling of depth. By working in the studio away from the demands of the subject, these changes in composition and color could be handled more easily.

Trying out new proportions

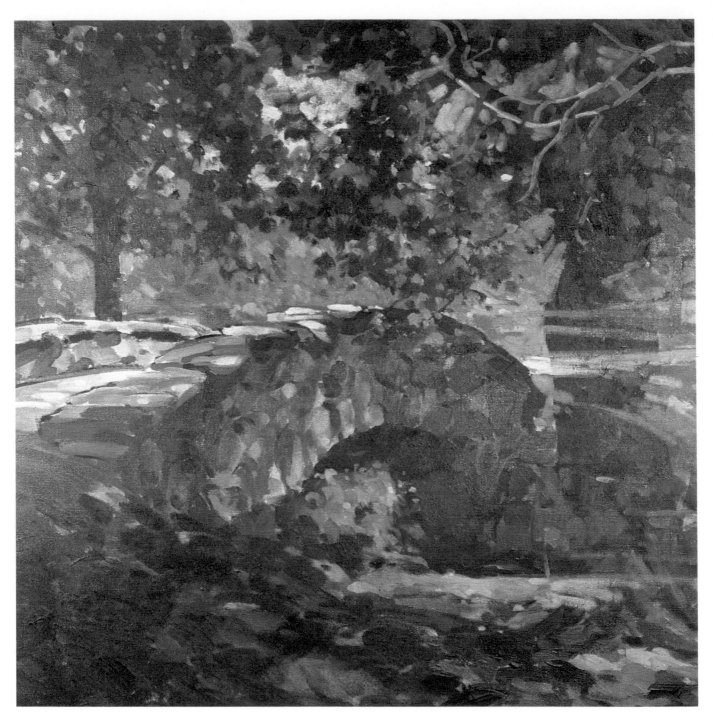

STEP TWO

After studying the painting's reverse image in a mirror in order to see it with a fresh eye, I decided on the necessary change: I redrew the foreground tree as a large branch coming from outside the picture. Using a small bristle brush, the branch was drawn in with a light color so that it would show up on the dark background.

In the area that needed to be changed I removed any heavy applications of paint by scraping or lightly sanding so that they would not show through the overpainting.

The sky was blocked in over or through the original foliage to open up the composition and to better define the distant trees. The road and foreground lights were changed in the same way.

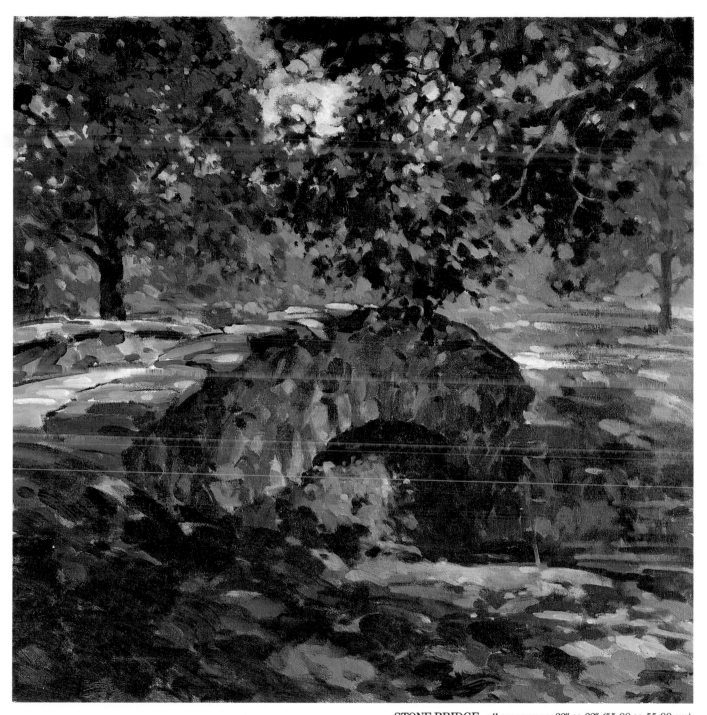

STONE BRIDGE, *oil on canvas, 22" × 22" (55.88 × 55.88 cm).*

FINISHED PAINTING
After blocking in the changes by paint-ing the background through the existing foliage, I began to develop further the foreground branch to separate it from the other trees. Keeping it stronger in color and value helps to achieve this distinction.

Incorporating a figure into a landscape

This painting was worked in a very direct manner. The initial drawing was made with a brush and thinned color, the tone of the canvas allowing me to place both dark and light values at the start. Since the tone of the canvas served as the middle value, the darkest darks and the lightest lights were established first to create a range of value to judge all other values against. I tried to keep the division of dark and light balanced in this painting by accenting light against dark throughout the picture.

Later on, when reviewing the painting in the studio, I decided to experiment with the addition of a figure. Carbon pencil sketches of a lone fisherman were made in different sizes and attitudes. Then, working on clear acetate, I made oil studies of the figures. These studies were placed over the painting to visualize the effect. Not only can these figures be moved anywhere on the painting to adjust for scale or effect, they can also be flopped in order to view the figure in a reversed attitude. New studies can be made to quickly study the effect of different colors or gestures; and all can be accomplished without touching the painting!

Once the figure was decided on and its position worked out, it was a simple matter to transfer the drawing to the painting. To do this, I used a tracing treated with soft pastel on its reverse side and then redrew the lines to transfer the image to the painting.

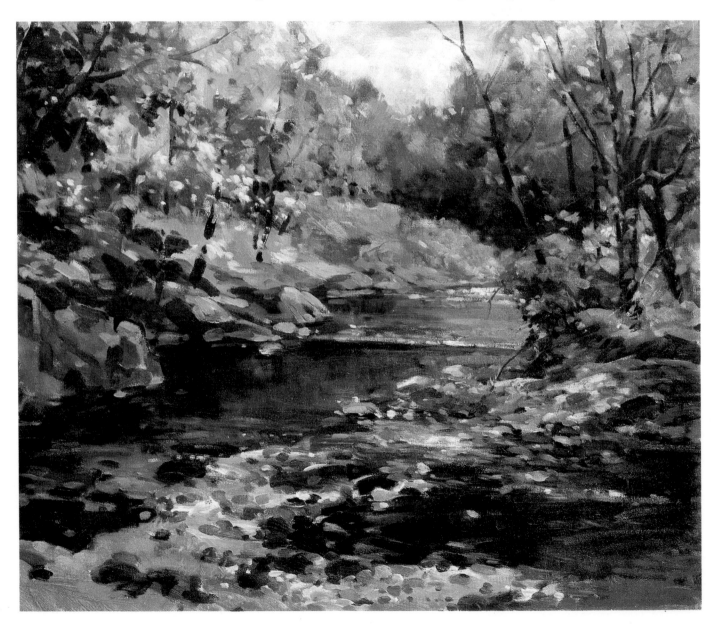

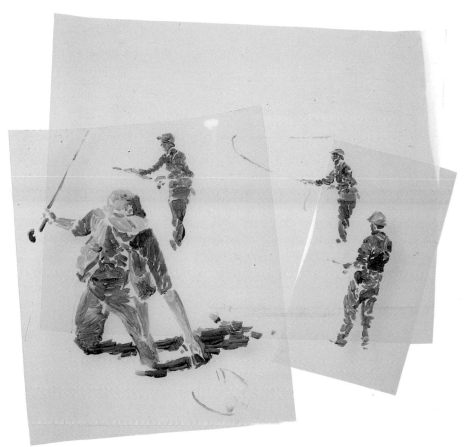

STUDIES ON ACETATE
These oil studies on acetate can be moved all around the painting, allowing you to pick from a multitude of positions. There are types of prepared acetate sheets that will allow you to work in water-based mediums as well.

PENCIL SKETCHES
In these sketches, I worked out the basic attire of the fisherman. I also made some color notes so I could anticipate what variety of color was going to be inserted into the original scene. I liked the idea of a touch of red in all that greenery!

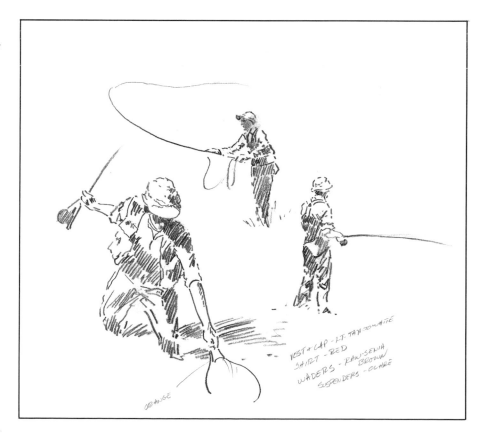

Incorporating a figure into a landscape

FIGURE VARIATIONS
The acetate figures were placed in various positions all over the painting until I decided on the position used for the finished painting.

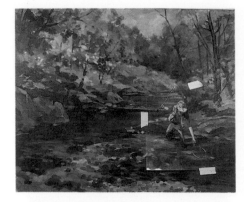

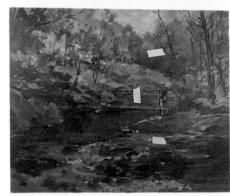

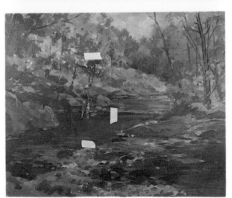

FINISHED PAINTING
Any heavy paint that was intended to be in the area occupied by the figure had to be scraped or sanded off before the figure could be painted in. The stream was painted with more varied strokes than any other part of the painting, ranging from the long, fluid strokes in the deeper pools to the short, broken strokes of the much shallower rushing water.

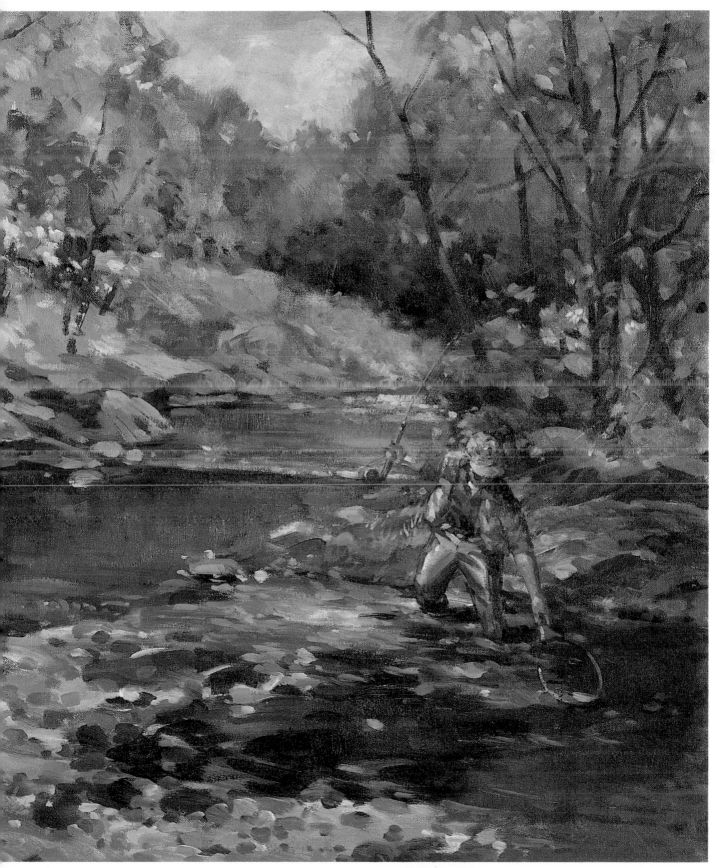

TROUT STREAM, *oil on canvas, 16" × 20' (40.64 × 50.80 cm).*

Creating strong design

Without the strong contrasts and vibrant color many paintings enjoy, an underlying design becomes even more important. So be willing to spend a little more time designing your painting; don't be in too much of a rush to begin. So often a student will be anxious to begin working on some interesting aspect of a painting and not spend the time necessary to create the strong, integrated design necessary for success. Remember, most of the mistakes in a painting are made right at the start; if they are not corrected quickly, you'll struggle with them throughout the rest of the painting.

Every line in the composition of this painting was planned to lead the viewer's eye back into the painting. The one light value was placed in the sky in order to silhouette the skyline. Note that the color on this foggy morning has been muted by soft tones that are all very close in value.

PRELIMINARY SKETCHES

Before starting a painting, I generally make some sort of black-and-white drawing to determine value and placement, or just to see how well the composition fits together.

This sketch, which is much like the finished painting, was quickly done with a marker. It convinced me that all the elements of the composition would fit well into the horizontal format I had chosen for the painting.

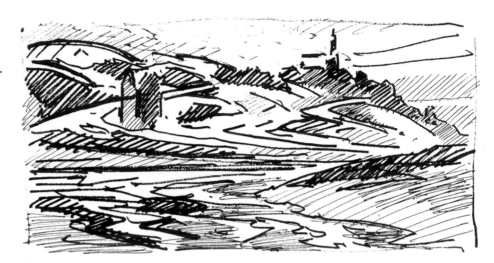

Here I had revised my original drawing to study another shape and design. Many times I will do a series of these drawings, usually taking them just far enough to visualize the design.

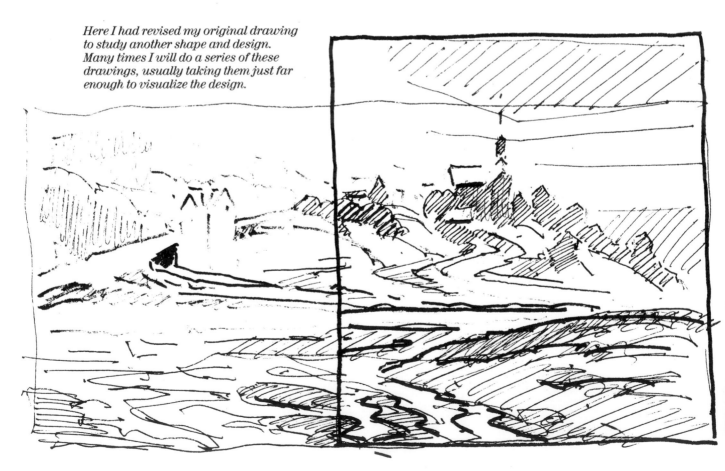

68

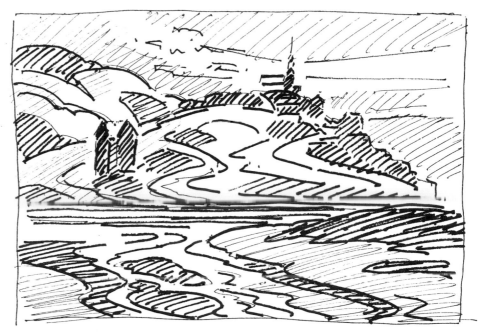

These final sketches exaggerate the height of the land and change the proportion of the painting. In the final analysis, I rejected them as being overly dramatic. In the lower drawing, I experimented by adding a number of small boats in the foreground.

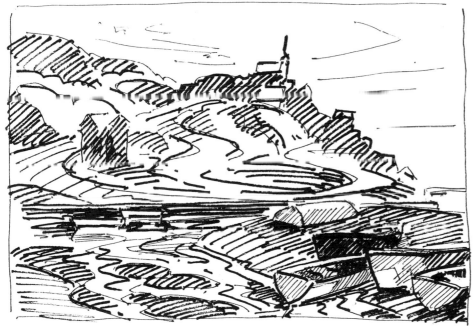

STEP ONE
I placed the large, simple shapes of this composition with soft vine charcoal, wiping off and redrawing until I was satisfied with the placement. The drawing was then refined with a brush and thinned color. For this type of drawing, I tend to use a small, flat bristle brush rather than a pointed sable. The sable brush encourages you to pay too much attention to detail. At this stage only the large shapes and compositional design should be important. Later these shapes can be broken up into more and more detail if you find it necessary.

Creating strong design

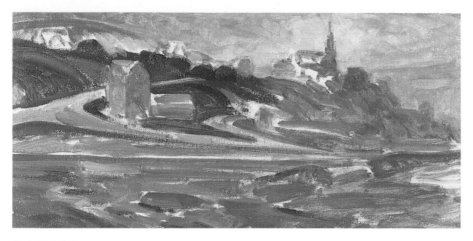

permanent green light raw umber

4-5

STEP TWO

The thinned underpainting in the second stage covered the canvas and established the general color and value of the painting. When an underpainting such as this has been freely done, much of the original drawing can be lost and must be established again before the painting can proceed. But this is preferable to painting in the drawing too carefully and ending up with nothing more than a colored drawing. This redrawing also allows you to reevaluate the composition and make any changes you may find necessary.

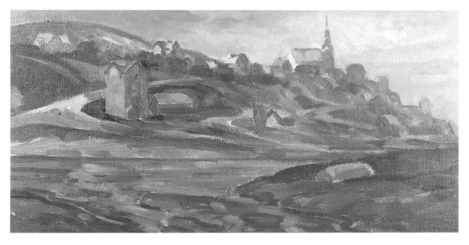

STEP THREE

At this stage I redrew some of the drawing that had been lost and added more detail to the building shapes before continuing with the painting. Working with heavier paint, I built up the color over the whole painting; the brushstrokes follow the contour of the hillside and create the pattern in the foreground water. Note that the buildings have been kept simple and are not much more than color shapes.

FINISHED PAINTING

To finish I worked back over the whole painting, simplifying shapes in some places and adding detail to others. I glazed over much of the hillside with a cool bluish color to more closely unite the buildings and the foliage patterns. I also decided to paint out the foreground boat; I thought it unnecessary and I wanted to place more attention on the middle distance.

mars violet cobalt blue

5

white

raw umber cobalt blue

3

white

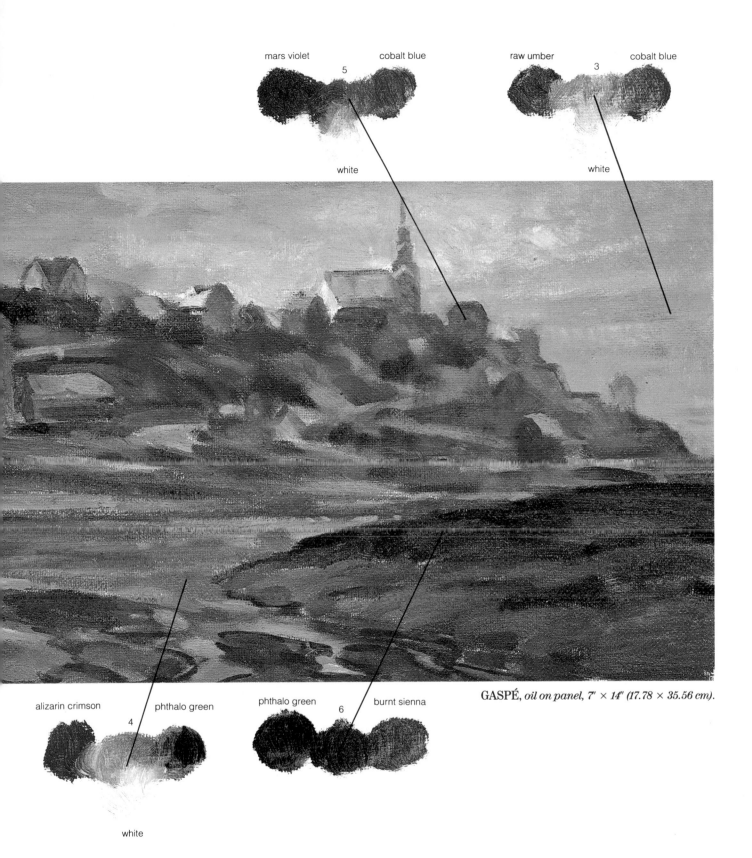

GASPÉ, *oil on panel, 7″ × 14″ (17.78 × 35.56 cm).*

alizarin crimson phthalo green

4

white

phthalo green burnt sienna

6

Finding the best format

This is a subject that could almost be thought of as a still life rather than as a landscape painting. Working from many photographs and black-and-white sketches, I composed the painting in the studio. The long, vertical format gave a feeling of height to the trees. This unusual shape dictated the painting's composition, so here I was not able to use the same divisions of space I would have if the dimensions were more standard. The figures add a secondary point of interest and a sense of scale. They also help to tell the story of the painting.

Although artists sometime regard compositional aspects as secondary, I have seen paintings ruined by lack of planning. I have seen my students try to condense a vertical subject into a horizontal canvas or squeeze a horizontal composition into a vertical format. The results are often disastrous, so a little more time spent in the beginning will benefit you with more exciting compositions and help to avoid many subsequent problems. Remember, most painting mistakes are made right at the beginning. If the initial design and concept are not right, no amount of good painting can change it.

PHOTO REFERENCE
The actual painting was composed from several photographs similar to this one. In this case, I used more than one photograph because I wanted to combine the most interesting carvings I could find into one design.

WATERCOLOR SKETCH
I did this watercolor as a quick study to place the values of the background. Accessing the background beforehand helps to determine the general overall design of the final painting.

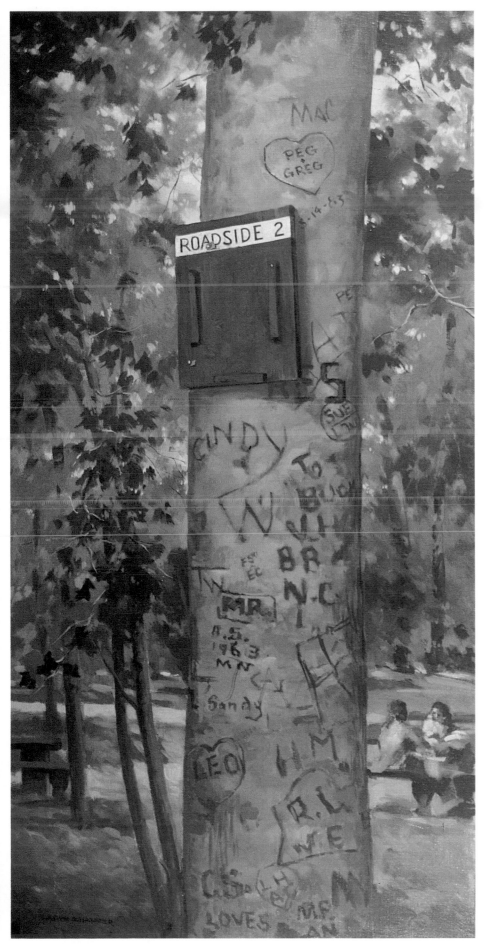

The carvings were intended to become a conversational element in the painting; to my thinking, they demand a closer inspection from the viewer. Note the addition of the sign; I included it in the composition because it's another example of man imposing language on nature.

PEG AND GREG, *oil on canvas, 30″ × 15″ (76.20 × 38.10 cm).*

Simplifying picture planes

This heavy stand of beech trees seemed an attractive subject, with their low branches offering a canopy against the light rain. Although it was raining when I first began to paint these trees, I thought that if the sun did decide to come out, it would only make this subject more dramatic.

For all its complex patterns, this subject has only two planes: the dark shadow of the foreground trees and foliage—and the light behind them. The light background plane does not need to be fully explained. I have used it only to define the complex patterns of the foreground. So I kept the light simple, not much more than spots of color, because to do more would have only created confusion.

Generally, the dark foreground plane was kept cool against the warmer light background. Even on a gray day, light can have a warm, luminous quality. Note that there are only slight changes in value throughout the dark canopy of the trees; interest has been generated solely by color changes within a close value range.

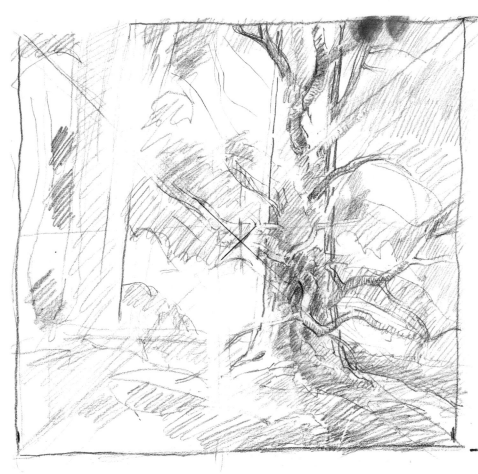

STUDY
Working from this study with the idea of doing a larger painting, I made new drawings to study the possibilities suggested in the branching. I also changed to a square design to add height to the trees. It's useful to think of the branches as tapering cylinders, especially for those that come forward and need to be accurately drawn as foreshortened.

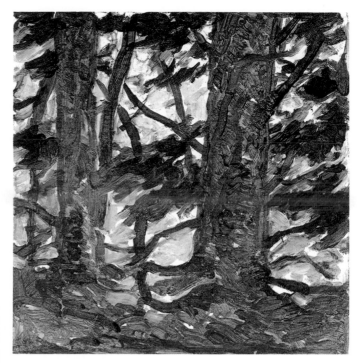

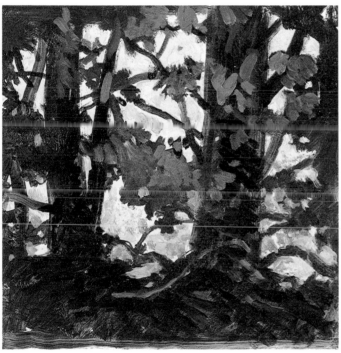

COLOR STUDIES
Color and value studies were done to visualize the effect of stronger sunlight and different color. It is interesting to note just how little the color has to do with the dramatic effect of the design.

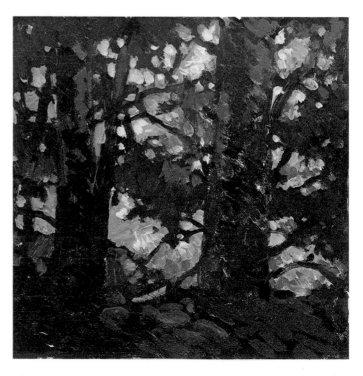

Simplifying picture planes

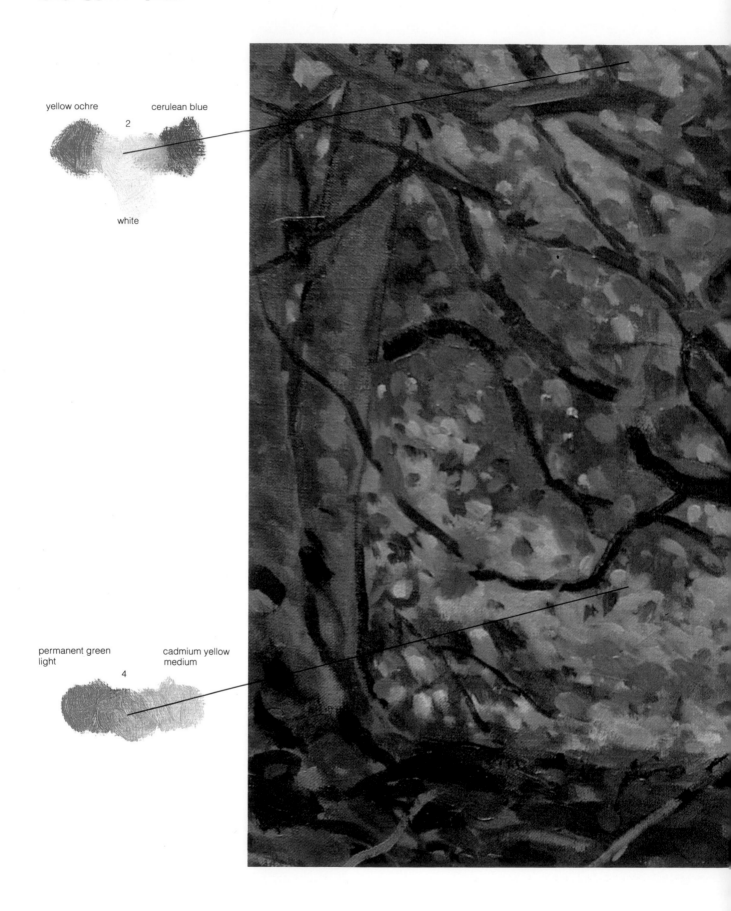

yellow ochre

cerulean blue

2

white

permanent green light

cadmium yellow medium

4

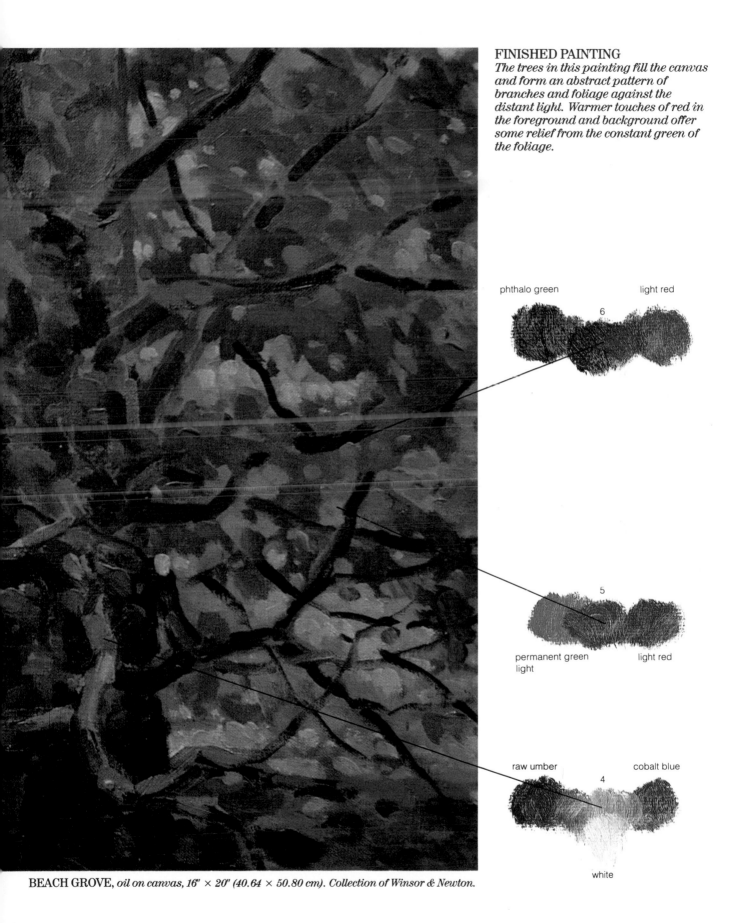

FINISHED PAINTING
The trees in this painting fill the canvas and form an abstract pattern of branches and foliage against the distant light. Warmer touches of red in the foreground and background offer some relief from the constant green of the foliage.

phthalo green light red

6

permanent green
light light red

5

raw umber cobalt blue

4

white

BEACH GROVE, *oil on canvas, 16" × 20" (40.64 × 50.80 cm). Collection of Winsor & Newton.*

Determining the real subject of a painting

This small study of a line of trees was painted on paper board that had been lightly sized with acrylic mat medium. The trees were drawn in first with carbon pencil but the finished work was completed in oil. My reference sources were some preliminary sketches that I had done on location. I also took several photographs of the scene to aid my memory.

Later, working from the sketches and photographs, I composed the painting in the studio. The horizon line was kept low to emphasize the height of the trees and the setting of the house. Instead of the actual road that goes by the house, which seemed too dark and overpowering, I painted in a shadowy bank of blue-patterned snow. I did this because the trees and their shadows are the real subject of this painting; the house merely indicates the scale of the trees and the depth of the subject.

This is an unusual composition painted much the way it was found in nature. In design it doesn't necessarily follow any rules of composition, but it does have a natural truth about it that keeps it interesting and helps it to work as a painting.

PHOTO REFERENCES
On a sketching trip, there is not always time to produce artwork. The camera allows me to record many more subjects or details than I would ever be able to do with a pencil or brush. When possible, I try to compose the picture in the photograph; and I always shoot closeups or details to support the main photo.

COLOR SKETCH
When time allows, I will make color sketches of important details or simplified color studies of the whole subject. Later in the studio all this material is brought together in composing the painting.

STEP ONE

The painting was begun by placing the trees and establishing the horizon with fine vine charcoal. At this stage, don't be afraid to make a lot of lines. They will help you to feel your way through a complicated composition and can be easily wiped off if you need to make corrections.

Once the trees were drawn in, the house was fitted in behind them and the shadow patterns were established. When I was satisfied with the placement, the loose powdery charcoal was dusted off lightly, leaving a faint image. The faint lines were then reinforced using a flat bristle brush dipped in color thinned with mineral spirits. With the same thinned color, I quickly brushed in the darks before going on with the rest of the painting.

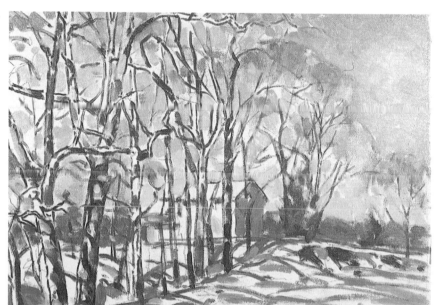

STEP TWO

The trees and the sky were brushed in at the same time, as I worked back and forth between them with applications of heavier color. The sky is a mixture of cobalt blue and light red with white changing to phthalo green and white at the horizon. Avoid painting the sky with simple mixtures of blue and white; it rarely appears that way.

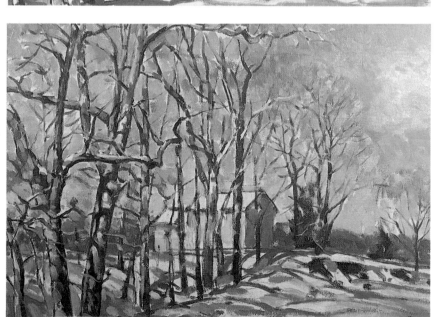

STEP THREE

Working from dark to light, I continued to work back over the whole painting to adjust color and value. The light areas of the snow are still the bare canvas. At this stage, don't be in too much of a rush to paint in these untouched light areas.

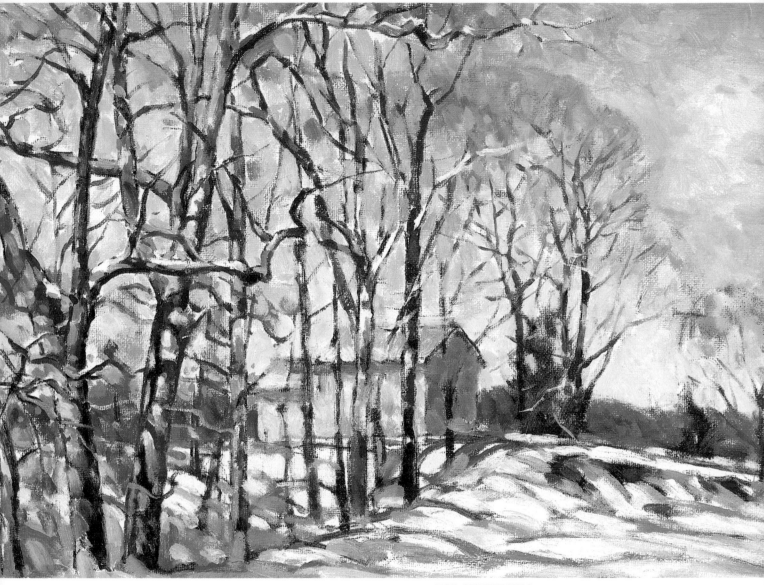

TOP OF THE HILL, *oil on panel, 10" × 14" (25.40 × 35.56 cm).*

FINISHED PAINTING
*In the final stages, I laid in the light
snow with a warm creamy white mixed
with yellow ochre, and then completed
the house to look more like the texture of
stone. Small branches and other details
were also added at this point.*

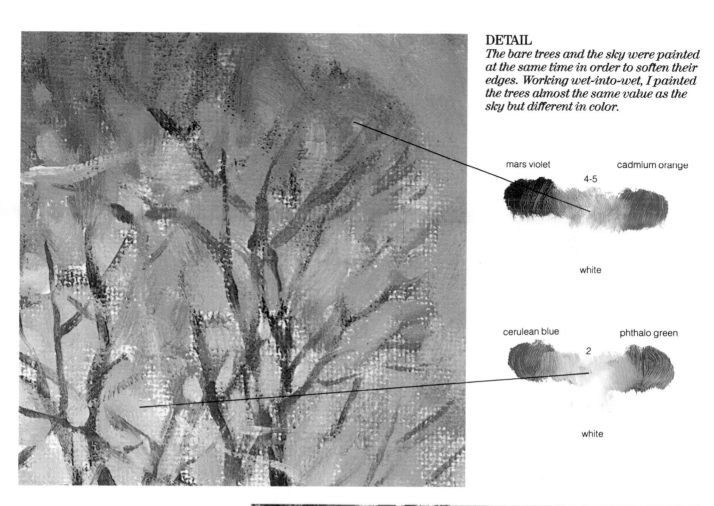

The bare trees and the sky were painted at the same time in order to soften their edges. Working wet-into-wet, I painted the trees almost the same value as the sky but different in color.

mars violet cadmium orange
4-5

white

cerulean blue phthalo green
2

white

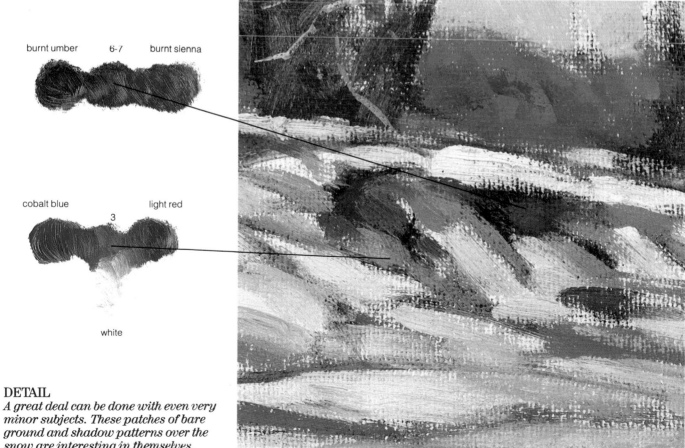

burnt umber 6-7 burnt sienna

cobalt blue light red
3

white

DETAIL
A great deal can be done with even very minor subjects. These patches of bare ground and shadow patterns over the snow are interesting in themselves.

Finding a focal point

At first look, this composition presents a very confusing arrangement of horses and riders. They seem to lead your eye in many different directions. But on closer inspection, all the riders are looking off to the right, so the viewer also tends to look in that direction. On the left, the horses are static, with their heads cut off or hidden, so I have drawn attention to the action of the central horse and rider. The distant treeline was composed to also bring the viewer's attention to the central action, which is directly below the tallest background tree.

In planning this composition, I made many drawings of individual mounted riders in relation to the background trees, as well as watercolor sketches to study the tree silhouettes and landscape.

On a gray, overcast day such as this, the background needed to be kept simple because there were no strong patterns of dark and light. I exaggerated the light behind the central horses to help bring attention to the action.

In the foreground the color and patterns are arranged much as the rest of the painting has been. Remember, you as the artist must be in control and arrange all painting elements. Very seldom will you find a subject where it has been done for you.

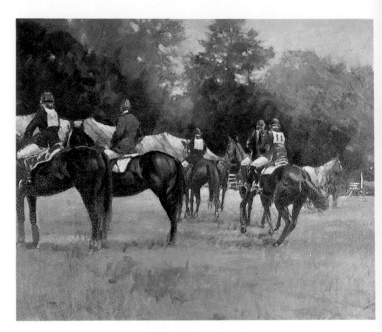

FINISHED PAINTING
The compositional sketch explains the directional forces that work to organize this seemingly confusing scene.

COMPOSITION SKETCH
The movement of horses and riders creates the composition. The viewer tends to look in the direction the riders are looking, which is back toward the central action. This creates a focal point of sorts and gives some order to the background. Note that the background of trees breaks at the focal point as well. The white horse, just by virtue of its whiteness in a sea of color, also serves as a minor or secondary focal point.

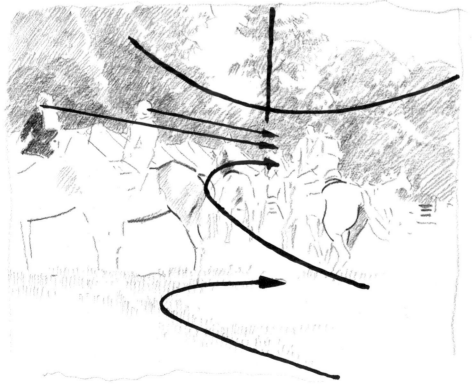

BACKGROUND SKETCH
This background was an attempt to develop the treeline, which is the landscape aspect of the painting. The central vertical tree divides the composition. If the background had been left a solid line of trees (as it was in the actual scene), the design of the composition would not have been as interesting or ordered. The lone tree stops your attention.

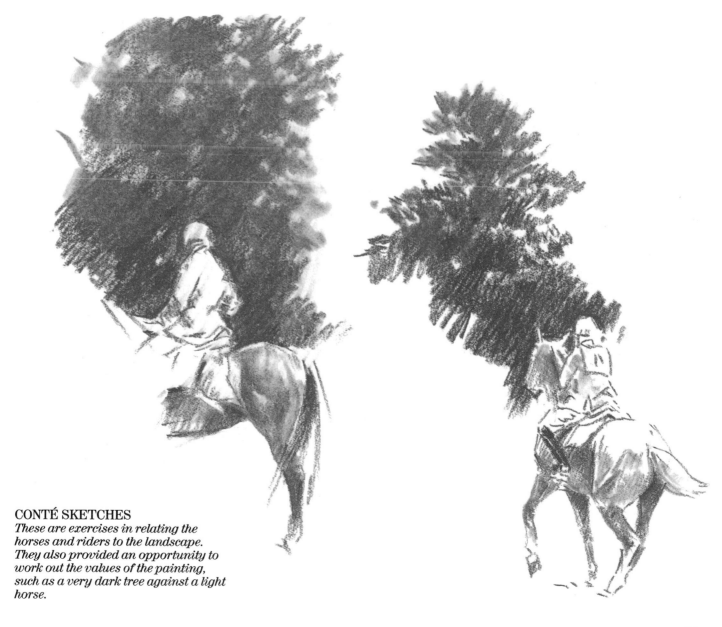

CONTÉ SKETCHES
These are exercises in relating the horses and riders to the landscape. They also provided an opportunity to work out the values of the painting, such as a very dark tree against a light horse.

Finding a focal point

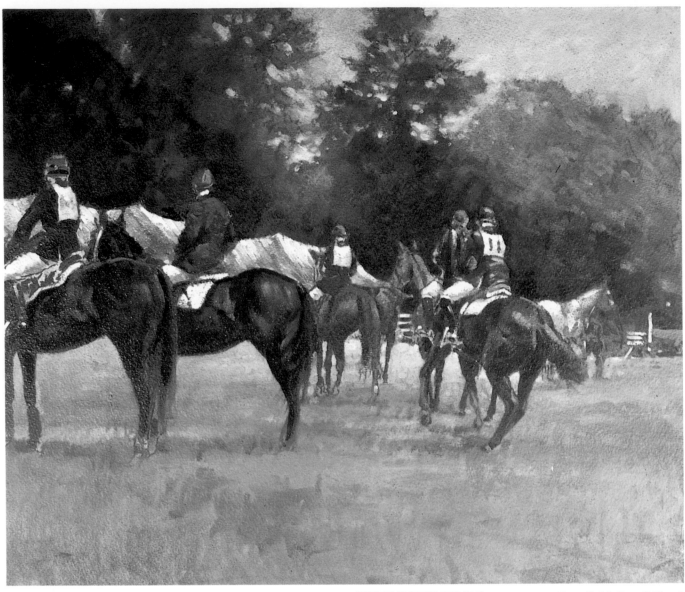

ESSEX HORSE TRIALS, *oil on paper, 15″ × 18″ (38.10 × 45.72 cm).*
Courtesy of Sportman's Edge, New York.

FINISHED PAINTING
This painting is an attempt to capture the excitement, movement, and general confusion of this type of subject in a landscape setting. The overcast day presented a problem here also. To create a wider range of values than the ones present at the site, I had to exaggerate the dark values of the trees.

The tree is basically a silhouette. It is the shape of the tree, and not the modeling of it, that makes it work within the context of the painting.

When the background was considered almost finished and completely dry, a sky-colored glaze of yellow ochre, phthalo green, and white thinned with lots of painting medium was dragged over the distant trees to soften the effect.

At this juncture, light is forced against dark. In actuality, the helmets were darker than you see them here.

Juxtaposing warm sunlight and cool shadow

The warm sunlight filtering through the trees and the cool shadow patterns are the real subjects here. The foreground horses only add interest; they could just as well be replaced by a picnic party or some other subject.

The three large trees with their dark foliage are reflected in a similar pattern of horizontal stripes in the foreground shadow. A similar balance is achieved between the cool shadows and the warm color of the sunlight.

A large part of the impact of this painting is due to its bright, yellow-toned surface. So don't always feel that a toned ground has to be a medium gray; make sure to try other colors and values. Whenever it's appropriate, adjust the tone for the particular painting or subject. In this case, the bright yellow tone helped to achieve the sunlit look I was after.

Note that accents of red in the horse and handler are a much needed complement to the green of the landscape.

TONE SKETCH
This rough sketch was done to show how important the yellow background tone was to this painting. By just establishing a few of the darks, I've suggested the whole effect of the painting. Note that the light is centralized in the middleground area.

COLOR SKETCHES

The oil sketch at top right shows that the subject of this painting is essentially a pure landscape. The figures and horses are just an added interest. The cows at top left were added to change the subject matter; they show that almost any object that fits naturally into a landscape would work here. The bottom two sketches point out the importance of color choice. The spot of red in the shirt adds color balance to the composition, whereas the blue does not. In this case, the eye calls out for red in the midst of all that green.

Juxtaposing warm sunlight and cool shadow

cadmium red yellow ochre burnt umber yellow ochre

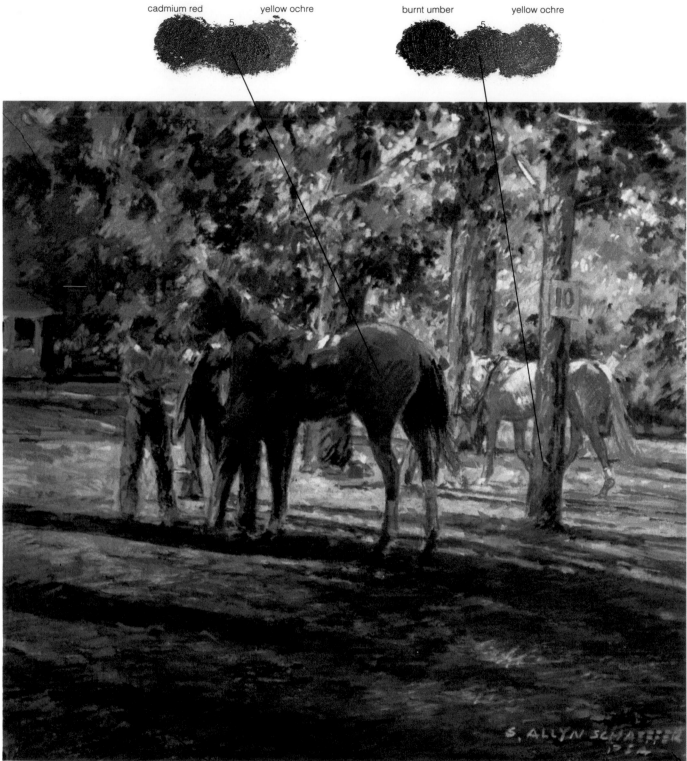

FINISHED PAINTING
The values in the finished work are more exaggerated than they are in the sketches. The feeling of intense sunlight and deep shadow is more the subject here than are the figures and horses.

ultramarine blue

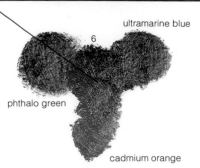

phthalo green

cadmium orange

SARATOGA, *pastel on paper,*
15" × 15" (38.10 × 38.10 cm).

DETAIL

*The yellow tone can be found through-
out the entire surface of the painting.
Although these trees look brushed in,
they are actually the background color
showing through.*

yellow ochre 3-4 white

cadmium orange

phthalo yellow
green 3 cadmium yellow light

Using light as a compositional force

Most of this painting is filled by a building with little or no architectural interest. The building silhouetted against the early morning sky also has little interest in color or value; I kept it in shadow to make it even less important and concentrated instead on the effect of light. So in this painting it is the light on the distant buildings and foreground boats that actually creates the compositional design.

The light enters the painting from the left in the sky and distant buildings, and seems to lessen in intensity as it moves around the building to the bridge and foreground boats. This trail of light effectively leads the viewer through the painting and is its main compositional force. The light is kept low in the sky to heighten the look of sunlight on early mornings near water. A successful landscape painting should describe a particular effect so well that it conveys a definite sense of the place and time of day.

Because of its size in relation to the painting, the main building needed some interest. Without adding too much importance to it, I tried to break up its surface with patterns of color and value changes while still keeping it in shadow. An important consideration here is the window treatment. Interest has been added by introducing as much variety as possible. I wanted to create some feeling as to what went on behind the individual windows. The windows with curtains, toward the front of the building, suggest a residential use; whereas the blocked-off windows toward the back create an industrial feeling.

Remember, not all the elements in a scene will compose themselves for the exact purpose of a carefully balanced composition. More often, the artist must sort through a myriad of detail to create a design that works.

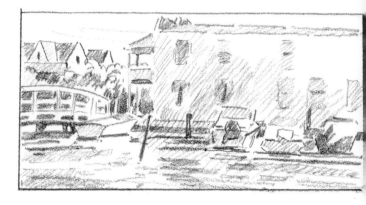

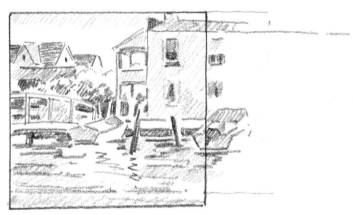

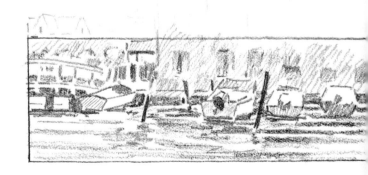

COMPOSITION AND VALUE STUDIES
Cropping is a technique long used by photographers as a compositional aid. The top sketch is based on the same composition as the final painting; the central sketch is cropped to a square format, which places more importance on the lone boat and minimizes the long building. The bottom sketch is cropped horizontally, almost in half, which focuses attention on the boats and their light patterns.

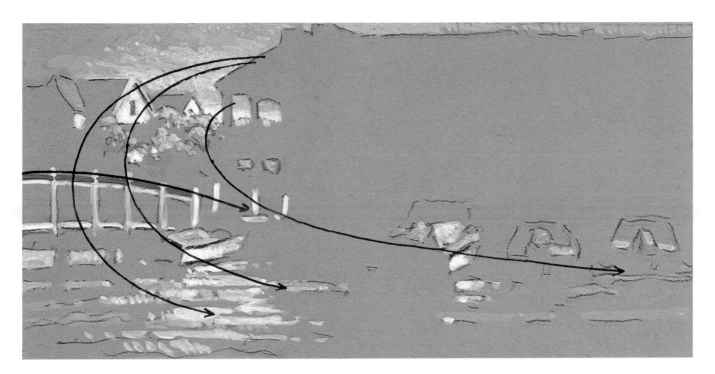

LIGHT SKETCH

The light was very selective as it touched on things throughout the painting. It is strongest behind the building and lessens in intensity as it moves to the right and into the foreground area.

OIL SKETCH

Because there is very little architectural interest or detail on the side of this building, I elaborated the differences I could find in each of the windows.

Using light as a compositional force

raw umber 5 permanent green light

FINISHED PAINTING
The intention behind this painting is to convey the effects of early morning light. Since the sun is low at this time of day, light tends to strike the sides of things rather than come from overhead. Note that the light is much stronger on the side elevations than on the roofs of the buildings.

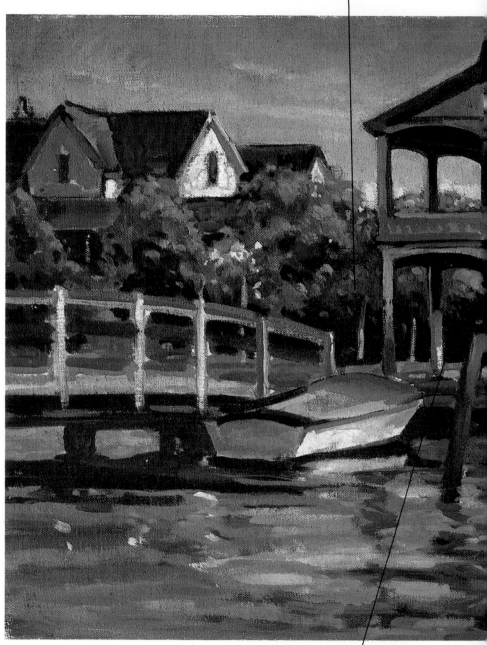

ultramarine blue 6 raw umber

permanent green light

raw sienna raw umber

5

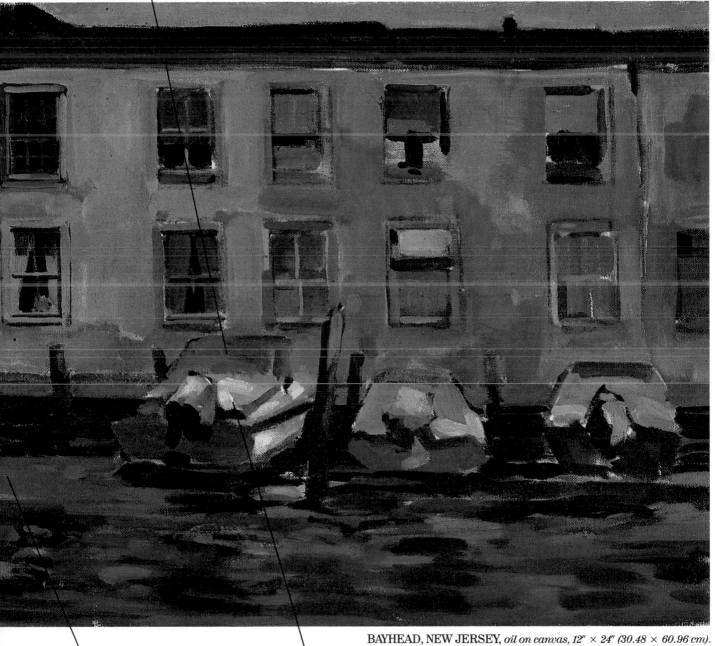

BAYHEAD, NEW JERSEY, *oil on canvas, 12″ × 24″ (30.48 × 60.96 cm).*

xture of raw umber,
rmanent green light,
d white cobalt blue

4

white yellow ochre

3

white

Dividing a landscape into planes

This composition is made up of three simple planes: the flat snow and ice of the lake; the slanting bank of the ground; and the vertical line of the trees. The arched vault of the sky could be considered a fourth plane. Its curved surface has several gradations of value that become lighter as they move toward the horizon line.

Value relationships change under different conditions, but if you keep the idea of three or four basic planes and values and decide just how light or dark each plane needs to be, it will make painting a landscape much easier.

PHOTO REFERENCE
The confusing detail of the massed trees and other patterns throughout this scene are much easier to paint when thought of as different planes with difference values.

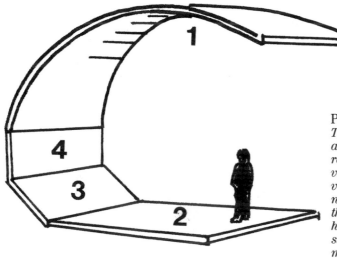

PLANE DIAGRAM
These are the main planes that make up all landscapes. These differing planes receive the light falling on them in varying degrees to create the main values in the painting. In this case, number 1 is the sky plane; its value is the lightest. Numbers 2 and 3 are the horizontal plane of the ground and the slanting plane of the hill; these are the middle values. Number 4 is the vertical plane of the trees; its value is darkest.

VALUE STUDY
This study translates the different planes of the landscape into their respective values: the light sky, the sloping mid-tone bank, and the dark vertical plane of the trees.

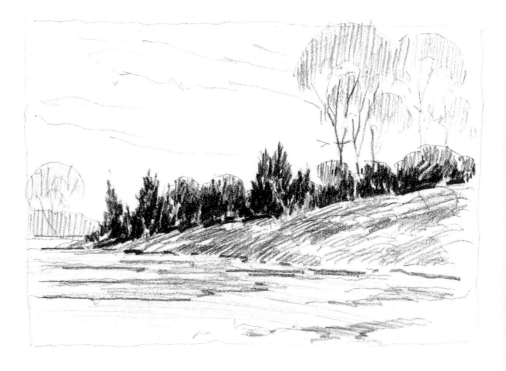

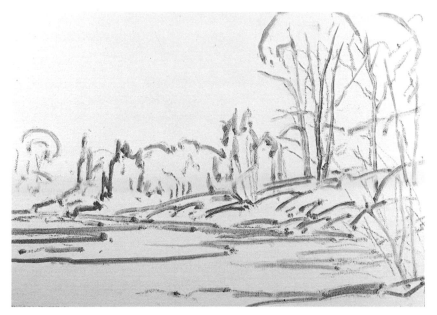

STEP ONE

After positioning the major planes and shapes with charcoal, I redrew the subject with thinned color, using different colors to separate and define each plane. No attempt was made to establish any detail at this stage. This drawing, or construction, as I like to call it, deals only with the large shapes: the patterns on the frozen lake; the contour of the shapes curling over the hill; and the big silhouetted shape of the massed trees.

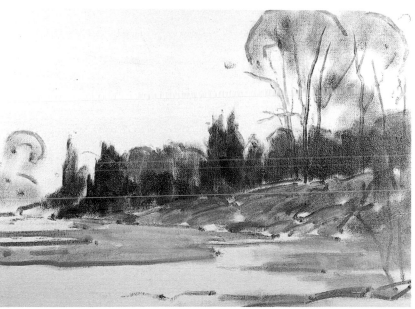

STEP TWO

Working back over the colored construction drawing, I used a medium-sized bristle brush to establish the four value divisions. Against the white canvas, I always start by establishing the dark plane first and then work toward the light. Remember that if you paint freely you are bound to lose some of your preliminary drawing. Feel free to go back and strengthen a drawing at any time during the painting process. Don't paint so carefully and precisely that you end up just adding color to a drawing, or you'll have a colored drawing instead of a painting.

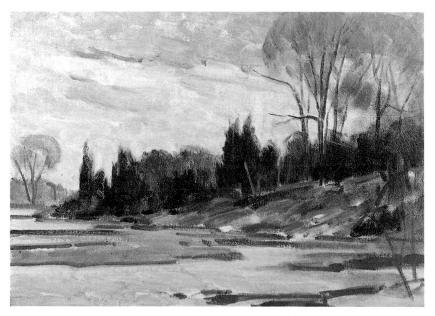

STEP THREE

If the darks are painted correctly at this stage, they will look very dark in relation to the white of the canvas. As you paint in the remaining areas, the value relationships will adjust themselves. Don't be afraid to exaggerate the appearance of the darks in the beginning. Paint the darks first and the lights will take care of themselves.

Dividing a landscape into planes

FINISHED PAINTING
After the three values of the lake, hill, and trees were established, I painted in the sky and redrew some of the fore-ground patterns. I repeated this fore-ground pattern in the sky to give it a little added interest and to strengthen the composition.

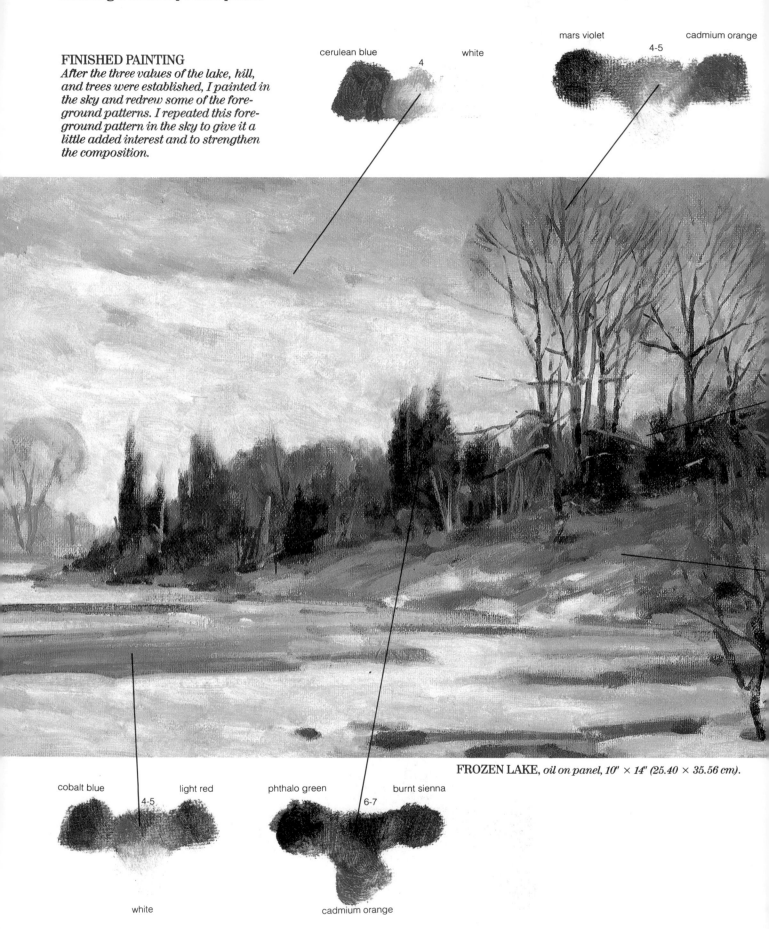

cerulean blue

4

white

mars violet

4-5

cadmium orange

cobalt blue

4-5

light red

white

phthalo green

6-7

burnt sienna

cadmium orange

FROZEN LAKE, *oil on panel, 10″ × 14″ (25.40 × 35.56 cm).*

DETAIL

The ends of the branches of the bare trees were painted in with a dry brush. Their color was dragged lightly over the dry painting of the sky. The heavier trunks were defined with thinned color and a small, pointed watercolor brush.

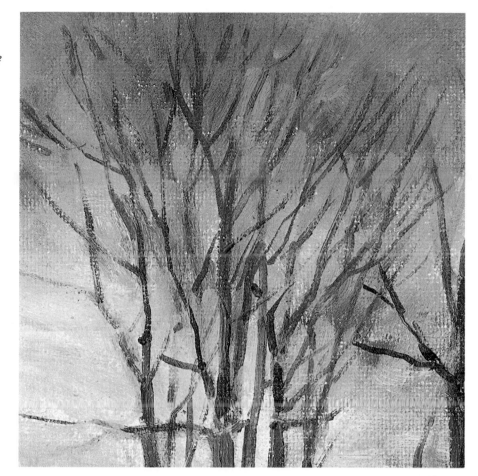

yellow ochre white

2

yellow ochre light red

4

permanent green
light

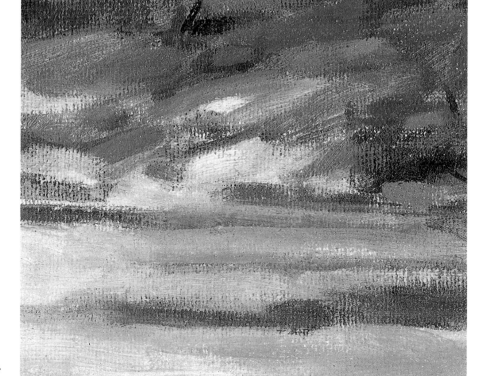

DETAIL

The flat expanse of ice and snow covering the lake was painted with long, flat horizontal strokes broken by patches of open water. This effect is contrasted by the short, choppy brushstrokes used to define the hillside and dark trees.

Incorporating architectural design elements

Don't avoid architectural subjects. Their strong design patterns can be used to create dramatic compositions. The architectural elements in this subject form strong design patterns in the painting. The foreground bridge effectively closes off the edges of the painting and focuses the viewer's attention on the central area of sunlight on the water. The abstract patterns of the water then lead back to the second bridge, whose arch repeats again the circular design of the composition.

The strong pattern of the foreground tree breaks up the arch of the bridge and keeps it from becoming too over-powering. The tree also adds needed foreground interest and disguises the severity that the bridge alone would create.

The placement of color is very controlled in this painting. There are just a few strong colors: the red building, the blue sky, and the green water. All three are centered in the arched frame that the bridge creates.

When viewed out of context, large portions of this painting form pure abstract patterns. Both the foreground water and the light branches against the bridge are examples of essentially abstract patterns.

COMPOSITION SKETCH
This drawing was done to point out the very strong foreground patterns and their repetition in the arches of the bridges.

COLOR SKETCH
The purpose of this sketch was to show that all the light and strong color of this scene are contained inside the arch of the foreground bridge.

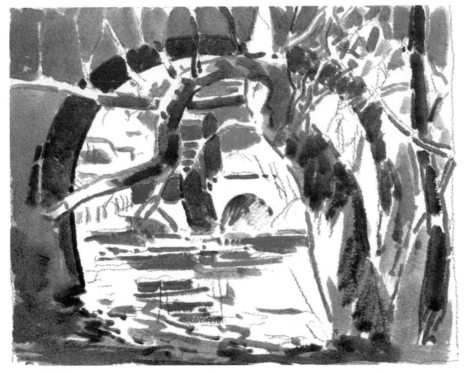

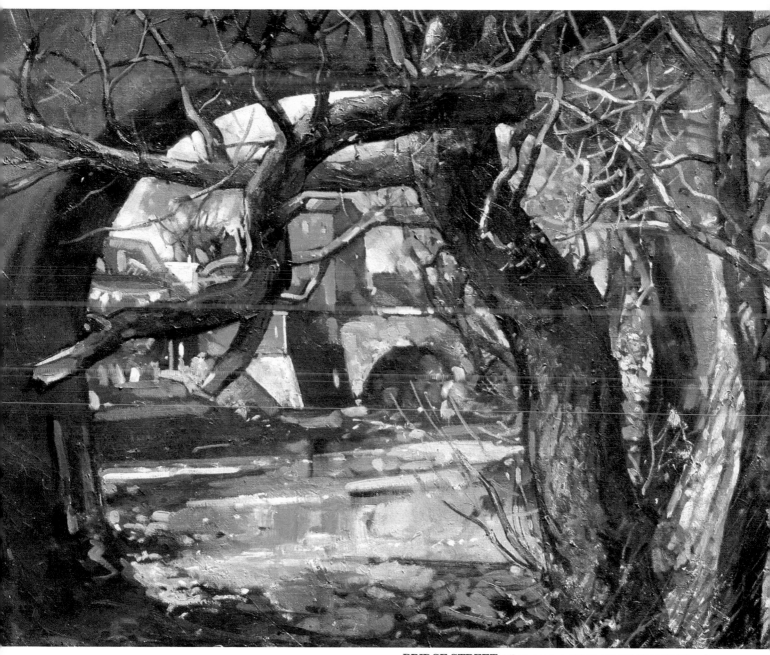

BRIDGE STREET, *oil on cvanas, 24" × 30" (60.96 × 76.20 cm).*

FINISHED PAINTING
The dramatic architectural elements in this painting are broken up by the twisting, natural forms of the trees. Note that the edges of the painting are intentionally kept dark to focus attention on the central interest area of the painting, where the only strong colors in the painting are found.

Incorporating architectural design elements

phthalo green 6 burnt sienna

phthalo green 5 cadmium orange

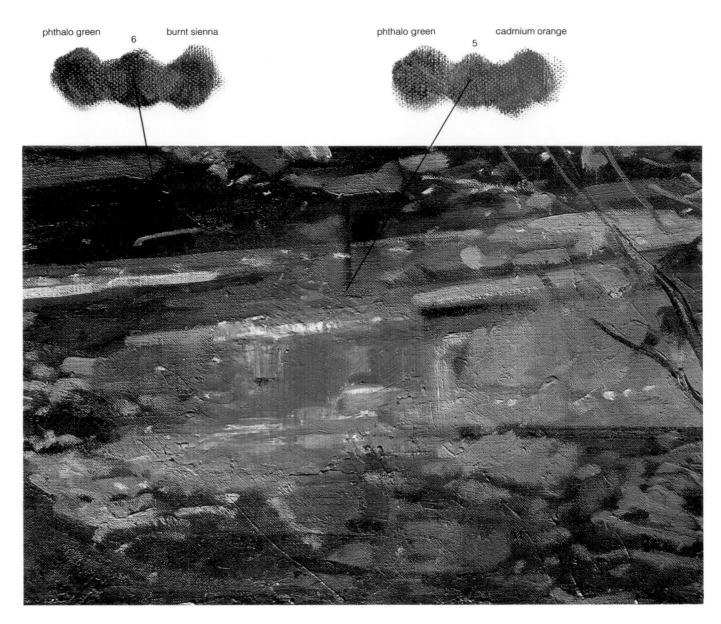

DETAIL
The water was laid in with just color and shape, creating patterns that are really an abstraction. If you separate this area of the painting from the rest of it, it would not necessarily suggest water. Note that the colors of the water are suggestions of the color found in the mirrored buildings.

cerulean blue yellow ochre

4

white

burnt sienna 5 burnt umber

cadmium orange

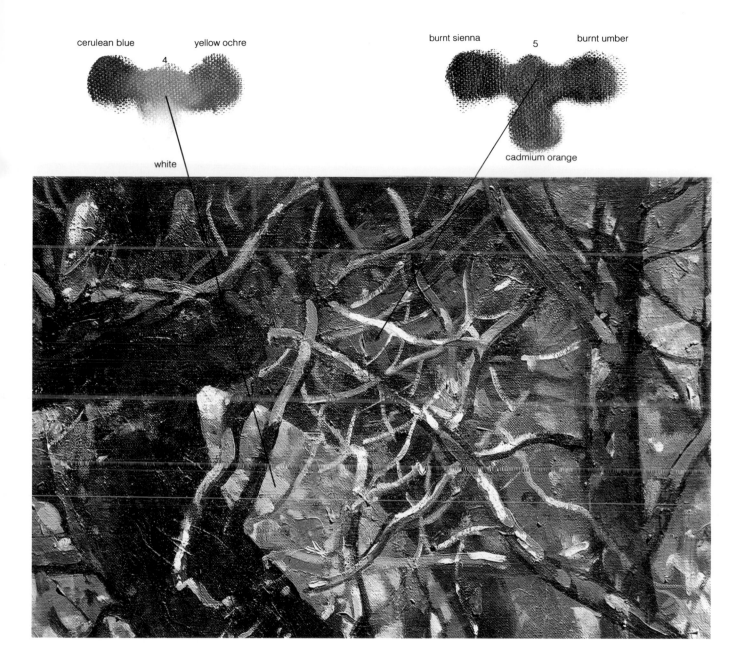

DETAIL

The tangle of small branches in this area is actually a small abstraction. The dark, negative shapes behind them are as important as the linear patterns of the branches. Note that this area is much warmer than other areas of the painting, its colors ranging from ochre to orange. Dark accents surround this area in order to set it off.

Using contrast to create the impression of strong color

This painting was done in Mexico, and in keeping with that country's sunlit landscape, it gives the impression of being very colorful. Actually it was painted in a very small range of color; a great part of the painting is really gray. The rest of the color is muted, broken only by the clear blue of the sky and the strong reds of the rooftops.

The dramatic interest in this scene resides in the church rising up against the sky. Notice how the sky patterns were controlled and used to add interest. These sky patterns and the dark foliage balance each other, dividing the canvas by a diagonal line that travels from the lower left to upper right.

The light foreground buildings were kept simple, as they were meant to form a secondary point of interest. The light verticals of the foreground buildings repeat the darker shapes of the church. Combined with the other buildings, these simple shapes lead your attention up the hill to the church and the late afternoon sky.

The grays that make up so much of this painting are very important, as they emphasize the strength of the reds. The foreground gray of the building was broken by many short, heavy brushstrokes, which vary in color and add texture to the wall. The grays in the sky are much smoother mixtures of one color blending into another.

INK SKETCHES
These are studies in patterns of dark and light; they were done to emphasize the different patterns of value within the painting. At bottom, I broke the composition into smaller patterns. The sketch at top shows a very simple pattern of very strong darks and lights.

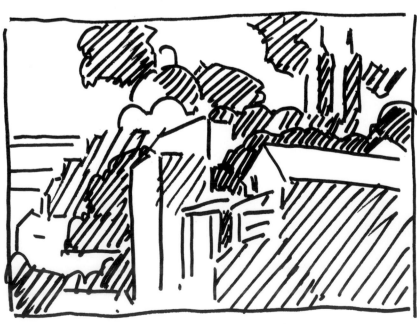

WATERCOLOR SKETCH

This sketch shows you how the color and value neatly divide into two diagonals. In this case it is not line but color and value that create the composition for the painting.

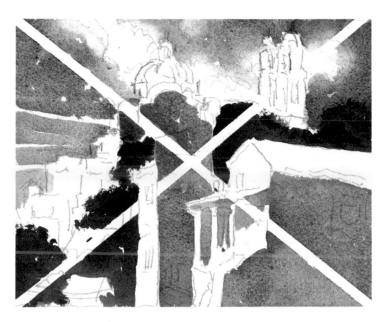

FINISHED PAINTING

Although there are only a couple of strong colors in this painting, the strong contrast makes it appear much more colorful than it actually is. I chose this simple color scheme because a limited palette often has the effect of emphasizing strong, bright color. If, for example, the red tone had to fight with other bright colors, it would probably lose much of its impact.

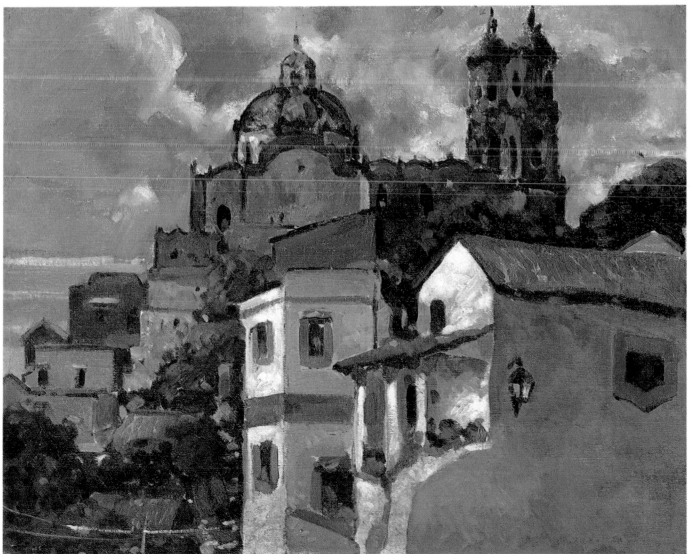

TAXCO CHURCH, *oil on panel, 16" × 20" (40.64 × 50.80 cm).*

Using contrast to create the impression of strong color

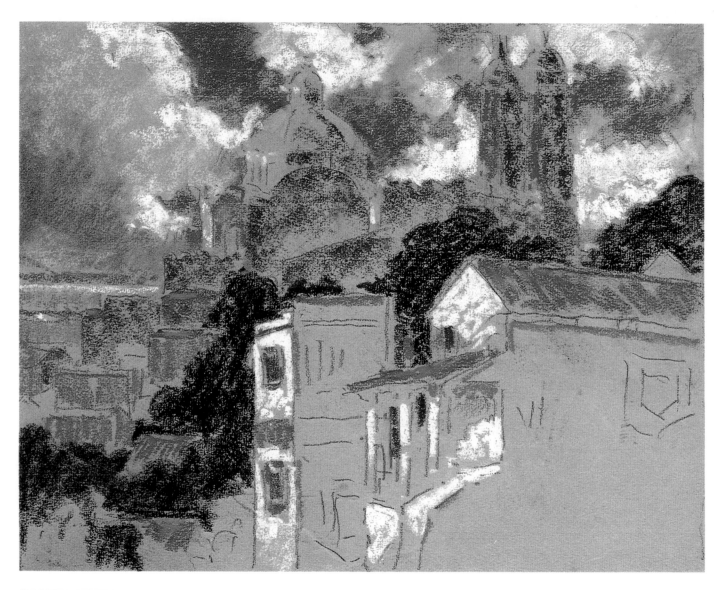

PASTEL SKETCH
This pastel sketch done on gray paper shows how a neutral background tone can become a major force in the composition. The gray also helps to set off the few strong colors found in the painting. This sketch points out the full-value range used here and in the finished painting. Value 1 can be seen on the facades of the buildings; values 6 and 7 are in the dark foliage. This wide range of value helps create the effect of strong sunlight.

DETAIL
With the exception of the white of the church wall, this close-up view reveals how very close in value most of the color areas in this painting are. Value contrast is provided only by the sky and the buildings.

cerulean blue phthalo green
 4

white

black cadmium orange
 4

white

burnt umber burnt sienna
 5

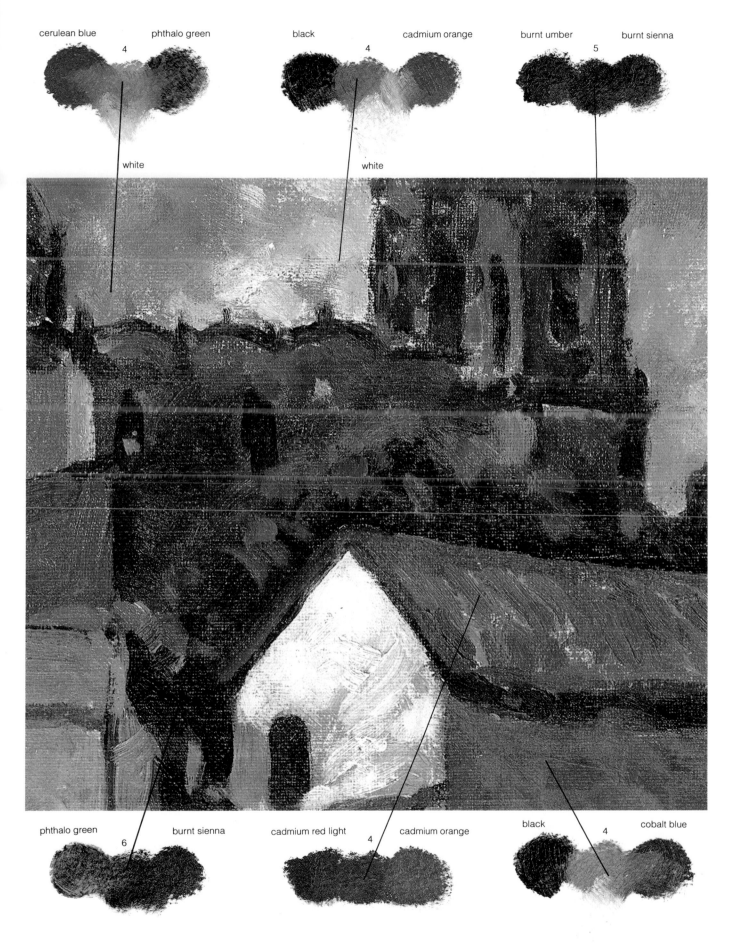

phthalo green burnt sienna
 6

cadmium red light cadmium orange
 4

black 4 cobalt blue

white

105

Suggesting mountainous terrain

The mountainous landscape of Mexico is so different from the landscape near my home in New Jersey that I was forced to look at it with new eyes. In this case, the cliffs were so steep that I thought the solution might be to almost completely limit the sky area. By doing so, I could more easily convey the sense that these mountains seemed to rise up in great masses from behind the village. To emphasize this nearly vertical landscape, I used long, definite brushstrokes to suggest the strong, interlocking patterns of the cliffs. Note that the distant houses and the red-tiled roofs are really not much more than spots of color that break up the heavy green of the mountain and help to define the scale of the entire painting.

When painting in a new location, whether it's only a few miles from home or in another country, it is always a good idea to take a little time to look around the site before starting to paint. Try to get a feel for just what is important in the scene before you. You'll find that you may not be able to paint the same type of composition that you would have in a familiar location. So if you are open to new ideas, new approaches to color, light, and design will invariably present themselves to you.

COMPOSITION SKETCH
This drawing was an attempt to show how the land masses in this area fit together in a geometrical fashion.

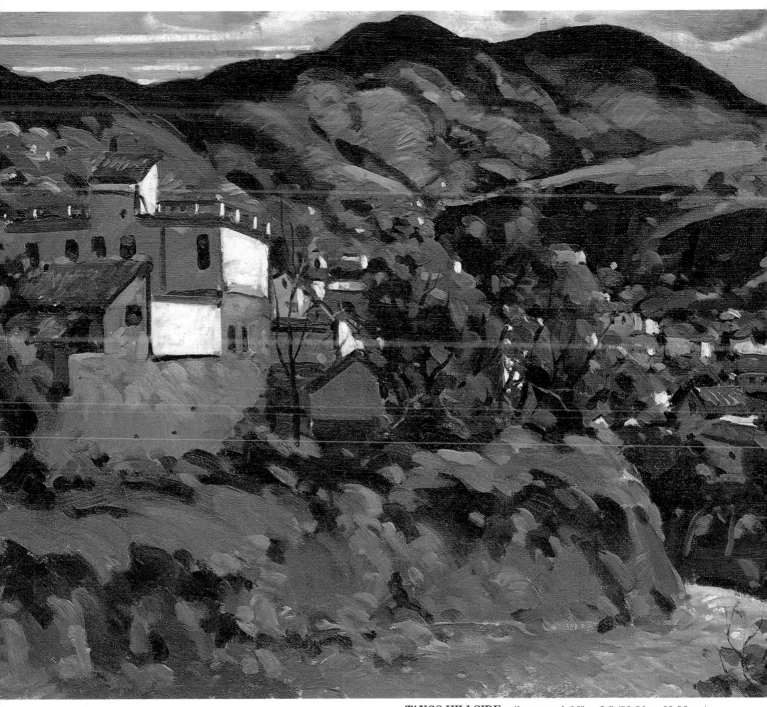

FINISHED PAINTING
The sky in this painting plays a minor role compared to the preceding painting on page 103. Its diminished size here is intentional and meant to convey the massive quality of the mountains behind the buildings.

TAXCO HILLSIDE, *oil on panel, 20" × 24" (50.80 × 60.96 cm).*

Suggesting mountainous terrain

WATERCOLOR SKETCH
In this color sketch, I have reduced the painting to simple shapes that are not much more than spots of color. Placing dark against light and warm against cool, I left areas of the green paper to serve as the middle values. This simplified drawing points up the strong design the painting was built upon.

DETAIL
The dark and light patterns of the hills reveal their rugged up-and-down quality. This dark/light juxtaposition defines the stark, jutting lines and strong value contrasts that would be characteristic of mountainous terrain.

alizarin crimson phthalo green
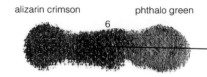

burnt sienna
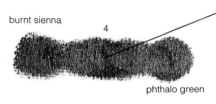
phthalo green

cadmium orange burnt sienna
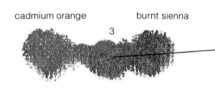

cadmium orange permanent green light
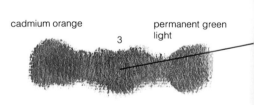

yellow ochre raw umber

Observing color changes

This painting provided a good opportunity to study the changes in color and value that can be found in a clear sky. Looking at the painting, you'll see how far it is from simple blue-and-white mixtures. There are at least four distinct changes in color from the overhead sky down to the horizon. Once you are conscious of these color changes, don't let them become a formula for painting skies. The sky is different every day and can't be painted well by following a formula. Look for its true color and subtle value changes.

The inspiration for this painting come from a slide taken on a sketching trip. I took it because the sky on that day was a particularly intense crystal-clear blue. Many times photos such as this serve as references for the details in a painting rather than as the primary subject of the painting.

The camera is an excellent way to record many more subjects than you can possibly capture with pencil and sketchbook. It is an especially good tool for capturing the fleeting effects of light and sky patterns.

PHOTO REFERENCE
I took this picture because I felt the bare trees were structurally interesting and the sky was a wonderful blazing blue. It was eventually used as a reference for several other paintings.

PENCIL SKETCH
The geese were drawn separately in order to study their general contours. In the painting itself, they are seen from below rather than from a straight-on profile. Even so, their forms are established enough in the drawing to capture their shape in the finished painting.

110

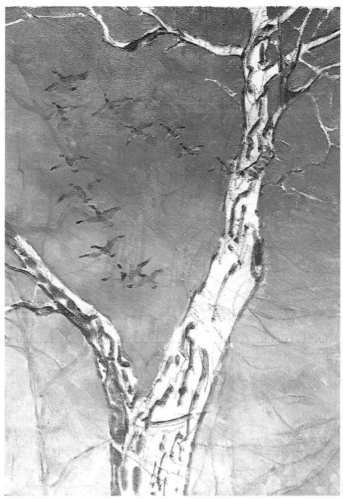

STEP ONE

My original intent was to paint this subject more or less like the reference slide. After the painting had been started, I changed this concept to include a wedge of migrating geese. As I thought about the painting in this context, I realized the trees covered too much of the sky to allow the birds to have any importance. The maze of lines in my original drawing attests to this fact.

STEP TWO

Working back over the drawing with heavier color, I painted out the unwanted trees and indicated the color in the sky. The arch of the sky was formed by a graded transition of color. It is darkest near the top with a violet-blue color that gradually changes to a truer blue. As the sky recedes toward the horizon, the blue becomes lighter and more green.

Observing color changes

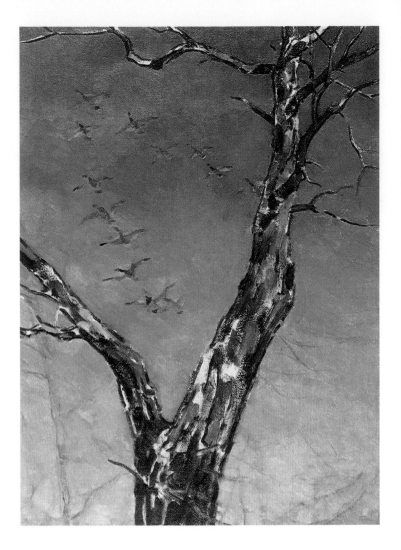

STEP THREE
Translating these sky bands to mixtures of oil color, I used cobalt blue plus light red to create the violet blue, which changes to cerulean blue, then to phthalo green, and then to yellow ochre. The horizon area was painted with a mix of cobalt blue and alizarin crimson. These colors were all mixed with white.

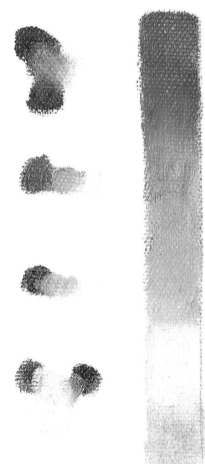

FINISHED PAINTING
In the final stages, I began to establish the color and texture of the tree. Working back and forth between the sky and tree to adjust their relationships, I redrew any forms that were lost when the sky was painted in. Finally, the birds were redrawn and completed and the foreground branches and accents brushed in.

COLOR BAR AND SWATCHES
This color bar shows the changing hues of sky color as it moves from pale violet near the horizon line to a bright, deep blue high in the atmosphere.

MIGRATION, *oil on panel, 14" × 10" (35.56 × 25.40 cm).*

Capturing light effects in clouds

This painting was an attempt to control all the elements in a landscape. Working from sketches and photographs, I arranged the shapes, color, and the light patterns much as I would if I were setting up a still life.

Since the shadows cast by the clouds in this scene moved quickly across the landscape and were constantly changing, I realized that they would have to be added to the composition in a pattern that would benefit the design. In a painting such as this, it is also helpful to have a little knowledge of the anatomy of a cloud. Note that the shadowed underparts of these clouds flatten out and are close in value to the surrounding sky area; the top part of the clouds is much warmer in color.

When the horizon is hidden, as it is in this painting by a land mass, the clouds still continue to recede back to the true horizon. They decrease in size until they vanish behind the mountain.

COMPOSITION DIAGRAM
This painting of cloud shadows is divided by repeating curved shapes. The arch of the mountain is reversed, or inverted, in the foreground snow; and the intervals of the other curved lines are varied to create an interesting pattern.

114

COLOR STUDIES
These oil studies were intended to capture the look of light on a heavily clouded but otherwise bright day. The changes you see could have happened in as little as half an hour. You can learn to use these shadow patterns to emphasize any part of the landscape. Forcing the dark and light contrasts will add to the dramatic effect.

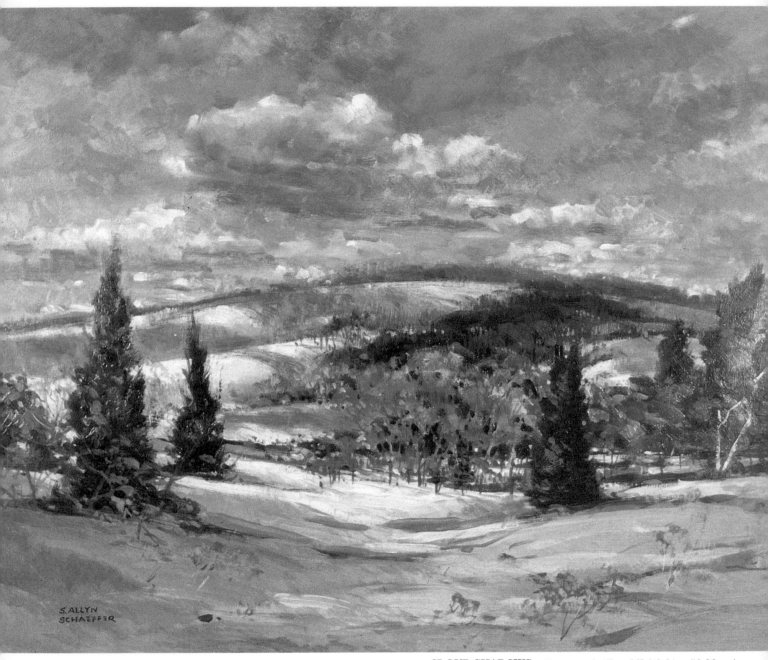

CLOUD SHADOWS, *oil on panel, 16" × 20" (40.64 × 50.80 cm).*
Collection of Mr. and Mrs. Peter Buckley.

FINISHED PAINTING
This painting is about the patterns of changing light that drifts over this hillside. It was put together both from direct observation and from the needs of the composition.

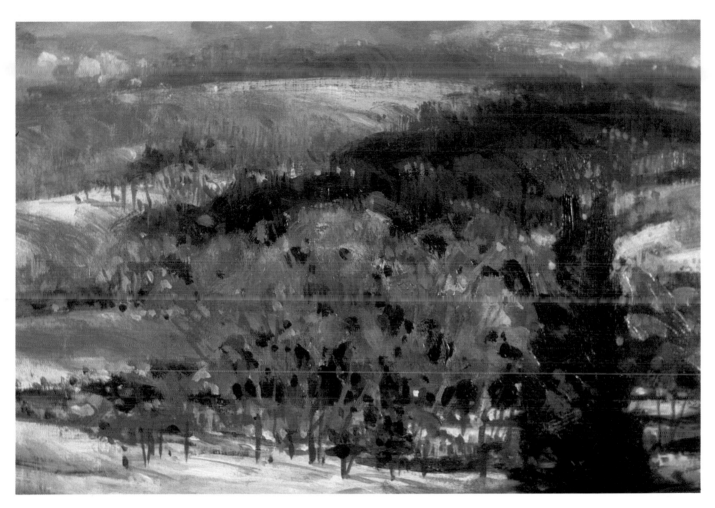

DETAIL

This area was worked back and forth between foreground and background, and between the lights and the darks. Here, the darks are painted on top of the lights rather than light over dark. Thus, the dark green has been painted over the yellow trees; this technique was useful for suggesting the lacy effects of the trees.

Positioning elements in a landscape scene

This painting is a very controlled composition that was developed entirely in the studio from many on-the-spot reference sources. Watercolor landscape sketches were combined with drawings of individual horses to study possible compositions. Using many small studies, I was able to experiment with different landscapes in relation to the attitude and placement of the horses.

To quickly develop the trial compositions, I worked on clear acetate placed over a watercolor landscape. With this technique I was able to visualize many possibilities without painting in the background each time.

Each horse was painted on a separate piece of acetate, allowing me to position it in different arrangements over the watercolor. The subject on the acetate can also be flopped over to reverse the image.

Different effects of light over the landscape and variations in color and composition can also be quickly suggested on acetate. The most successful of these experiments were further developed as small pastel studies in preparation for the larger oil. However, many of the small studies and drawings become finished works themselves. Sketches on acetate overlays can often be used later on in subsequent projects. Prepared acetate is available in different sizes and will accept most media, including watercolor.

WATERCOLOR SKETCH
This color sketch was done to show the color and value of the trees at the edge of the field; it was also done to show the background that the horses were to be placed in. Since in this case I wanted to make the horses the important subject, the landscape becomes supplemental to the subject and is in effect just a foil or backdrop for the horses.

CONTÉ SKETCHES
Basically drawn in the studio, these studies were done to observe the structure of the horse. You will note that one of these horses was used later in the oil painting and another was used in the pastel.

MARE AND FOAL, *pastel on paper, 8″ × 10″ (20.32 × 25.40 cm).*
Collection of Ann Kent.

PASTEL

This drawing was thought of as a preliminary to the finished oil painting. After it was completed, I thought the horses would be a stronger element in the overall painting if one was looking up at the viewer. One reason to use pastel in this context (as a preliminary to a finished work) is because it's faster; but also because pastel translates well in terms of its final appearance and in general working procedures to oil color.

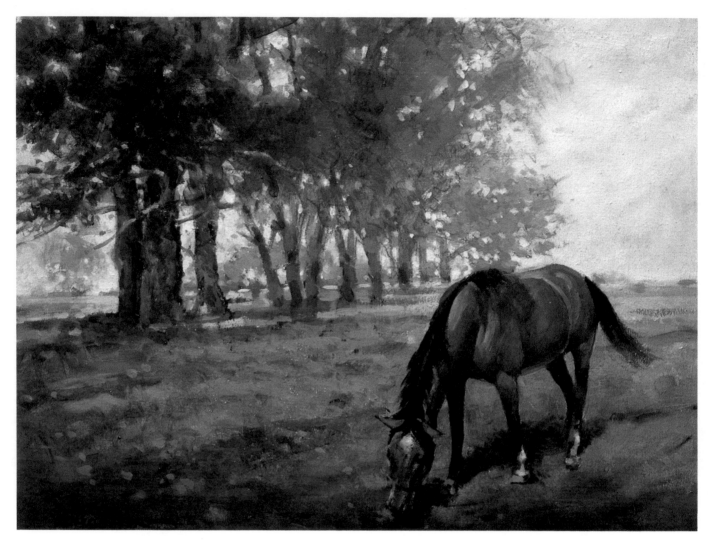

PRELIMINARY OIL PAINTING
This painting was executed very fast in order to plan the placement of the horses in the landscape. After some consideration, I thought the mare required a more regal posture, and thus really needed to have her head up looking at the viewer. Also, I felt that the angle of the horse in this painting looked a little distorted.

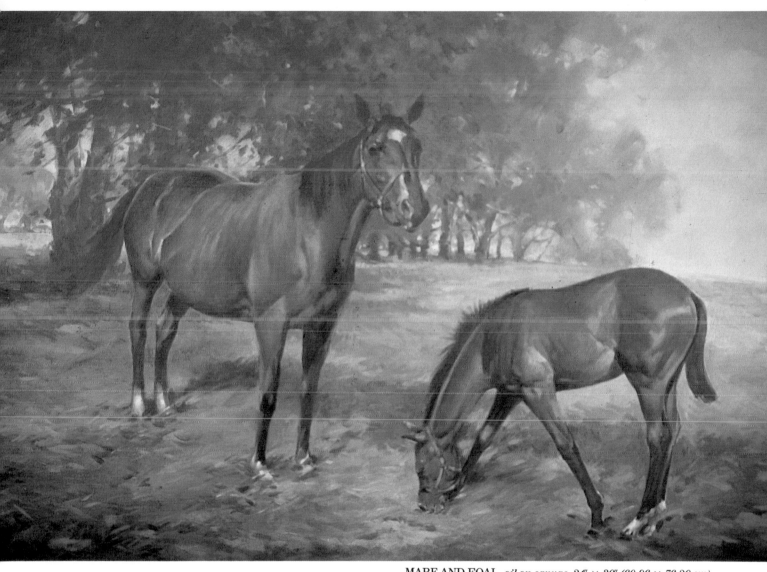

MARE AND FOAL, *oil on canvas, 24" × 30" (60.96 × 76.20 cm).*
Private collection.

FINISHED PAINTING

This painting is a compilation of all the others. I tried to take some of the best things from the other drawings and paintings and make this one the best solution. For example, the landscape comes from the small oil painting and the foal is from the Conté sketch.

Using light to enhance the subject

This painting is really a very direct sketch completed on the spot, without any additional studio work. It came about mostly by chance. I had been working on another subject and was about to leave when the suddenness of the changing light made this particular scene a compelling subject.

There was no lay-in or preliminary wash for this work; I used color just as it came from my palette, with no medium. The color and value of the entire painting were established with short strokes of heavy pigment. These are not much more than spots of color that make little attempt to describe detail.

The centrally positioned birch trees become the main interest here as they are set off by the surrounding foliage and a clear blue sky. Since the effect of light is of paramount importance to this painting, I tried to give the light a very consistent look throughout the scene. That is, the light that falls on the light-colored birch clump should be of the same color and value as the light that is present throughout.

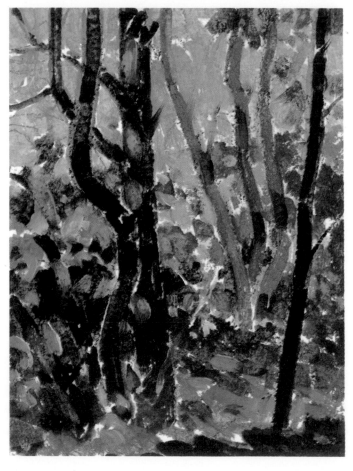

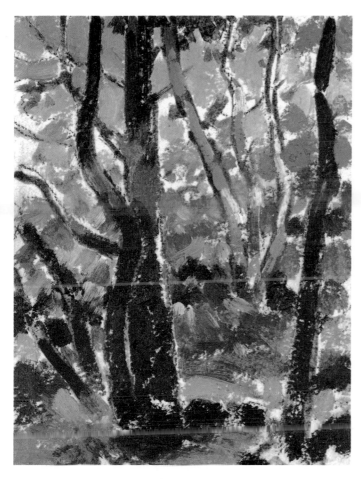

LIGHT/COLOR STUDIES

As the light moved across this grove of trees, it continually changed the appearance of the scene. In the sketch at top left, the light was concentrated behind the trees, revealing them as not very interesting silhouettes. At top right, the sun was higher in the sky, lighting the middleground but leaving the foreground in shadow. Note that the light falling on the birch clump gives some hint of what is to come—the full light of the finished painting. The bottom sketches show the light concentrated in the foreground area, as the sun had come full circle.

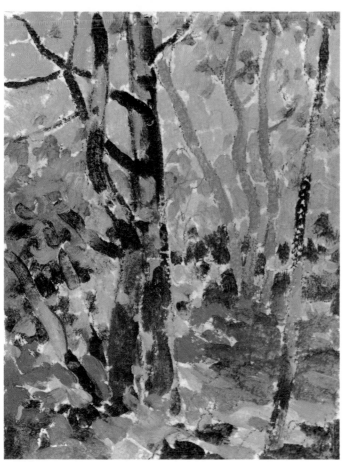

Using light to enhance the subject

DETAIL
The birch clumps in the central-right area of the painting were made more dramatic by darkening the sky behind them and by the dark leaves at their base. The cool whites have been made warmer by the addition of a little yellow ochre.

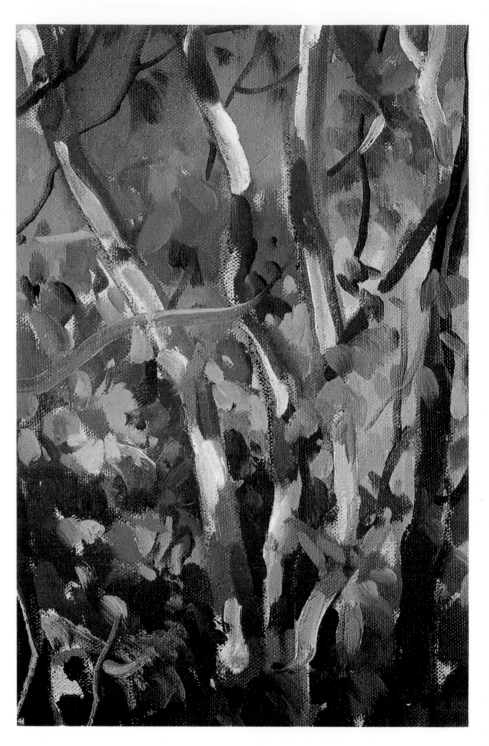

FINISHED PAINTING
This painting is based on a composition composed by nature. That is, I saw this scene and knew it would work as a painting just as is. It was painted quickly with short, bold strokes to capture the effect of light filtering through the trees. In a heavily wooded area such as this, the light can change very quickly; it's important to keep a consistent look so that the light appears to fall on every part of the picture in a similar manner.

TREE GROVE, *oil on panel, 16" × 12" (40.64 × 30.48 cm).*

Balancing strong and muted color

I have painted this stream many times at different times of the day and in all seasons. It is the type of subject that can change dramatically with the season and can always be relied on to be an exciting subject to paint. Different aspects of this subject can be emphasized to create many different paintings.

When painting an autumn landscape such as this one, don't be overcome by the brilliance of the foliage. Look for the green in a yellow or orange tree, and always be sure to establish the darks. If everything is in high-key, the lights will invariably lose their potential for dramatic effect.

To emphasize the drama of this bright fall afternoon, I tried to balance the intense, sunlit fall colors with the more muted color found in the shadows. Instead of always trying to make the lights lighter, paint in the darks first and the lights will tend to take care of themselves. Avoid adding too much white in the lights; they will seem much brighter without it. And, just as the lights should not be too white, the darks should not get too dark or black. Try to keep both lights and darks colorful.

DETAIL
In this generally dark area, the effect of light is still very important as it filters through the trees, highlighting individual branches. Note that the darks in this area are not dull, but are kept as colorful as the lights.

FINISHED PAINTING

Strong contrasts of sunlight and shadow help to balance this painting. The unequal balance of dark and light is an important consideration in painting. Color balance is another consideration here: even on this late fall day, there is still a great deal of green to balance all the reds and oranges.

FALL STREAM, *oil on canvas, 24" × 36" (60.96 × 91.44 cm).*
Collection of Mr. and Mrs. Greg Closs.

Seeing the landscape as a still life subject

There are many natural materials that can be brought into the studio to form the basis of a painting. With just a few props you can recreate some subjects without the problems of changing light, difficult weather, or any of the other rigors associated with outdoor painting. For this painting the branch that supports the hornet's nest was set up in the studio. This way I was able to control the light and experiment at leisure with the best placement of the nest. (You can think of this procedure as similar to building and lighting a stage set.) Eventually, the nest was placed almost dead center on the canvas, and I composed an imaginary landscape around it from memory. To convey the somber, muted mood of this painting, I worked in close values and an almost monochromatic range of color. Often, I find that technique needs to suit the subject. This painting required a smoother application of paint, as I felt that heavier brushstrokes would detract from the mood of the gray winter landscape.

For the distant landscape behind the nest, I used a stiff bristle brush and thinned color to spatter in the texture. The spatter effect helped to unite the background and suggest the look of light falling snow.

PENCIL STUDY
Focusing on the nest without the background allowed me to study it separately. The pencil drawing helped me to better understand the nest's contribution and texture before attempting to paint it as part of the landscape.

COLOR STUDIES
Upper left: A monochromatic color scheme sets up a wintry mood. These closely related colors and a limited value range are much like the effect of the finished painting. Upper right: This is a variation of the first study, with the nest moved to the right, a simpler background, and a higher horizon. Lower left: This long-range view didn't seem to work, as it adds too much distance in the background area and takes interest away from the nearby nest. Lower right: This view has a wider range of color and value and a more overgrown setting. It's not what I wanted for this painting but it may be a good subject for a later painting.

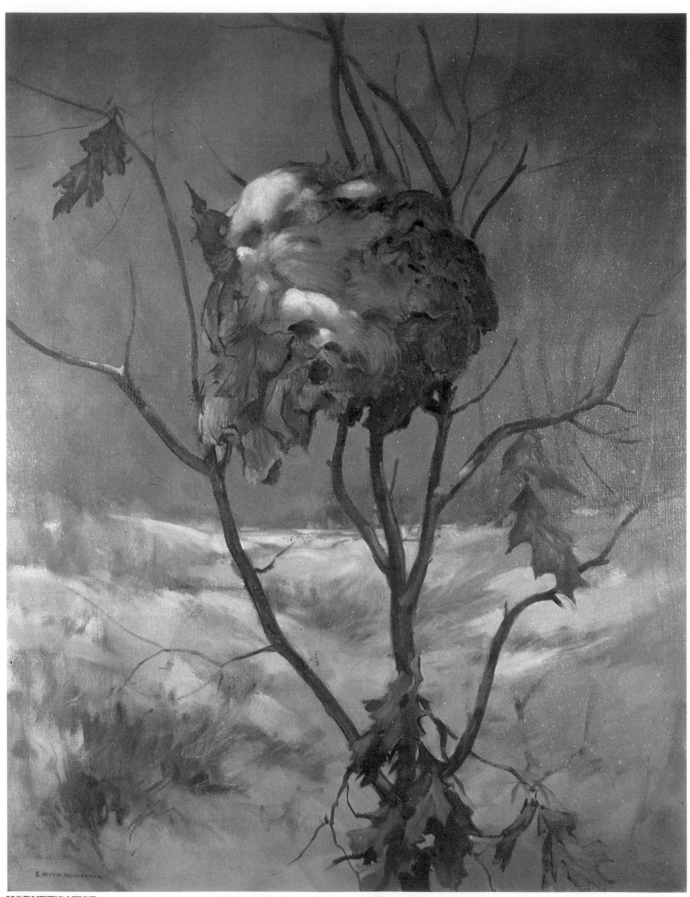

HORNET'S NEST, *oil on canvas, 30″ × 24″ (76.20 × 60.96 cm). Collection of Mr. and Mrs. I. Gyorgy.*

FINISHED PAINTING
This painting is all about mood. The limited color and close values combined with the image of the leftover nest evoke the starkness of a winter landscape.

DETAIL
This distant tree is treated as a silhouette against the dark sky. Thinned white or gray color was spattered from a stiff bristle brush to suggest the effect of lightly falling snow.

DETAIL
Even though it's not painted in a very detailed manner, the nest area is the most refined part of the painting. This draws attention to the nest and sets it apart from the rest of the painting.

Working from color memory

This city landscape is dominated by strong vertical shapes, which are echoed by its narrow format. To offset the vertical shape of the church, the sky is made up of horizontal forms, and so is the foreground street area. These very simple shapes are made more complex and interesting by soft, subtle colors and suggestions of detail.

Color and light are the most important elements in this painting, more so than the shapes that make it up. The sole reference for this work was an old black-and-white photograph of the scene—and my memory. Because my reference was so limited, I was freer to invent my own ideas about how color and light should form this painting than I would have been if my reference had been in color.

The raking light over the front of the church picks out architectural details. It also breaks up the dark vertical shape of the church and adds needed interest. Note that the light was used very selectively to highlight certain elements while leaving others in shadow. Also, the effect of strong light on the looser, organic shapes of the trees softens the more angular architectural forms of the buildings behind them.

I included the lone automobile in this scene because somehow I thought it added to the mood of the painting; it also defines the scale of the buildings. The clouds are nearly brown in color, but altered somewhat by small patches of blue changing to purplish tones in the late afternoon sky. This same warm tone was used throughout the painting to help unite all its elements.

WATERCOLOR SKETCH
In this simple watercolor diagram, I have tried to reduce the composition to the large masses or patterns that make up the painting.

PHOTO REFERENCE
This church turned out to be a wonderful subject for a landscape painting. If you are receptive to new subjects, you will find you can paint anywhere.

132

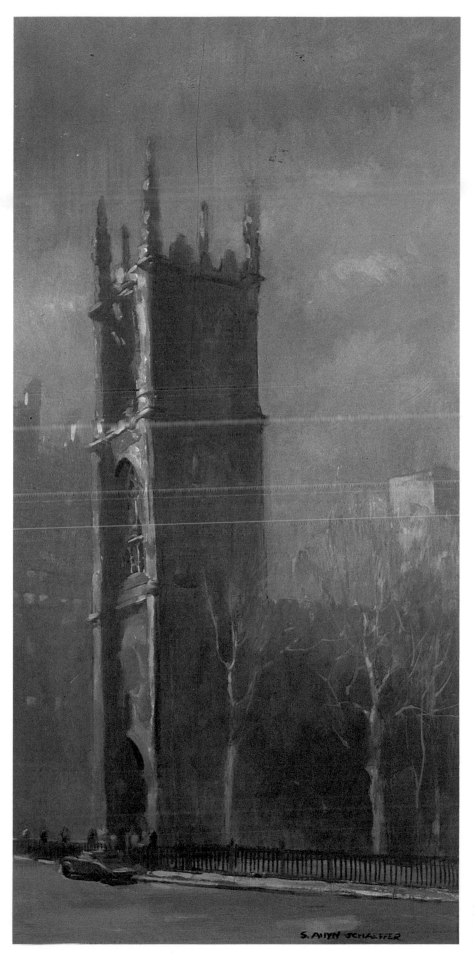

S. ANN SCHAEFFER

FINISHED PAINTING
Working from a black-and-white photograph as my only reference, I had to apply the color from memory. Although this may have some obvious drawbacks, working from memory also allows me to more easily control the color.

NEW YORK CITY,
oil on panel, 24" × 12" (60.96 × 30.48 cm).
Collection of Mr. and Mrs. I. Gyorgy.

Working from color memory

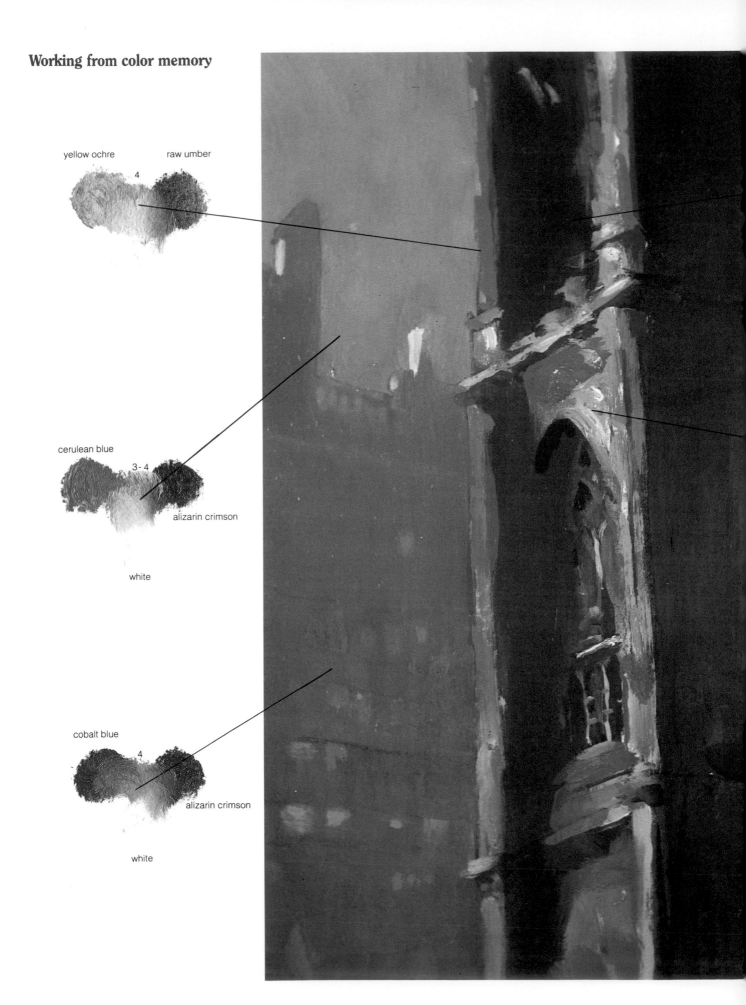

yellow ochre raw umber

4

cerulean blue

3- 4

alizarin crimson

white

cobalt blue

4

alizarin crimson

white

burnt umber cobalt blue

6

burnt sienna

yellow ochre cadmium orange

3

DETAIL
Here, it's easy to see how simply the Gothic forms can be suggested in the arched windows. If they had been painted in with more detail, they would have been out of keeping with the loosely brushed look of the rest of the painting, thus making them look too important.

Varying perspective on the same subject matter

When doing a demonstration for a group or class, I often repeat the same subject but from a different perspective. It is really quite fascinating how just a subtle shift in point of view can transform identical subjects into unique images.

For these three demonstration paintings, I worked from very small watercolor sketches that were done on location. They have very little detail but were enough to refresh my memory. Once the initial composition had been established, I didn't refer to the sketch again. By painting from memory I was better able to concentrate on the main effect and forget all the nonessential landscape elements that have a tendency to crowd out the primary focus of a painting.

Painting from memory can be a decided help in rearranging the subject material. As these paintings developed, other solutions to composition, color, and light suggested themselves, letting the painting itself dictate how it should be completed.

WATERCOLOR SKETCHES
These simple watercolors served as notes for demonstration paintings. I kept them extremely simple in order to allow me to make changes. Without detailed sketches, I was able to add or subtract elements as I worked.

FINISHED PAINTING
This piece is an example of a subject I paint often: a shaded foreground area that looks into a middleground area filled with light. Note that the shadows follow the contours of the snow and are arranged in such a way as to draw attention to the bright middleground snow and to the strong color of the distant trees.

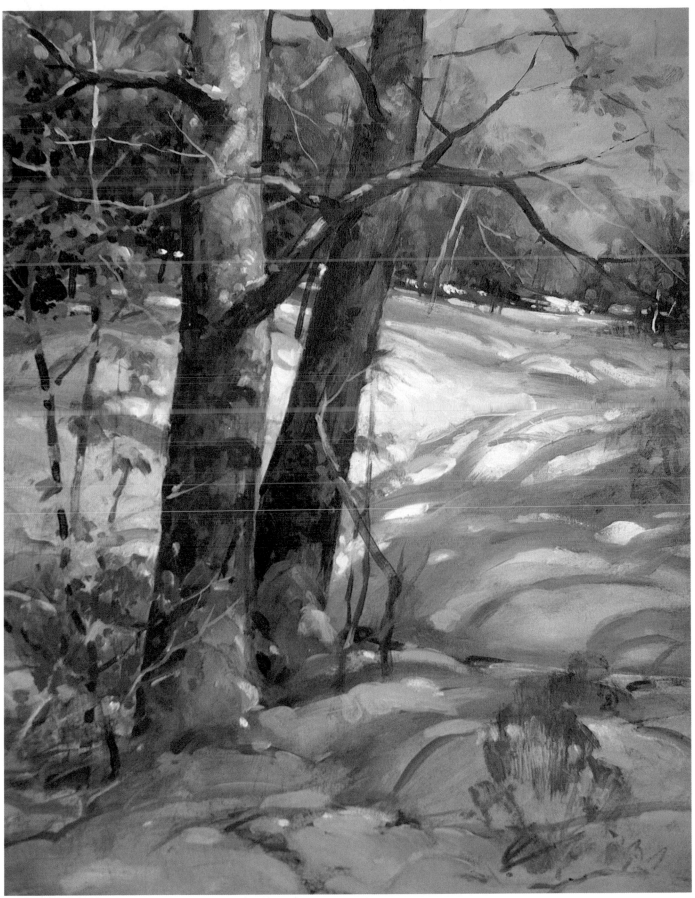

VARIATION No.1, *oil on panel, 16″ × 20″ (40.64 × 50.80 cm).*

Varying perspective on the same subject

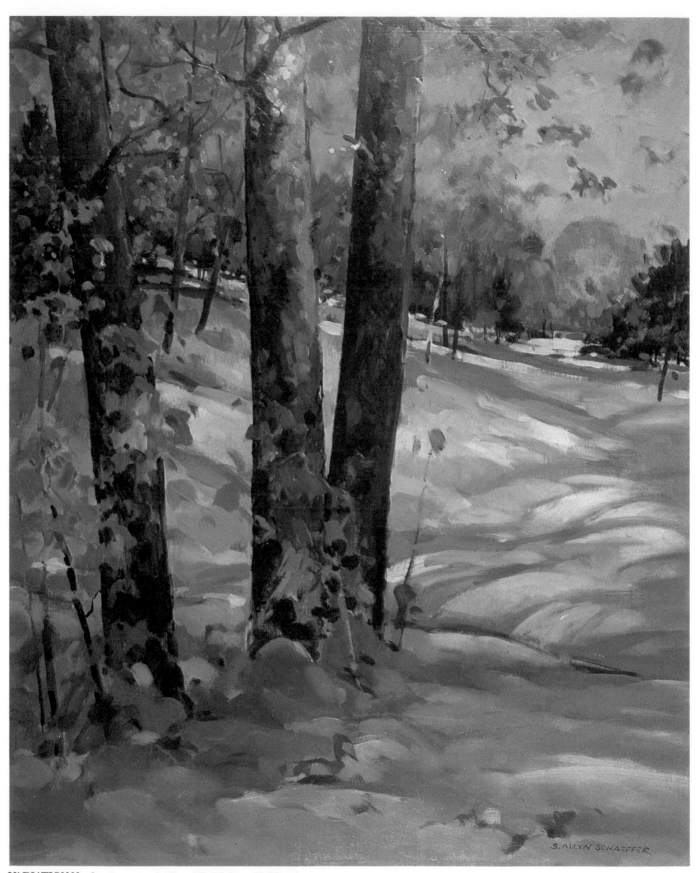

VARIATION No. 2, *oil on panel, 16" × 20" (40.64 × 50.80 cm).*

FINISHED PAINTING
The effects of light transform this simple subject into something much more interesting than you might think at first glance. Keeping the light behind the foreground trees adds to the depth of the painting.

DETAIL
Here the light seems to come from directly overhead, which causes the upper part of the branches to be more heavily lighted and the foreground area quite dark.

DETAIL
The suggestion of leaves in front of the trees adds a great deal of interest to the painting and makes a lively contrast to the strong vertical of the tree trunks.

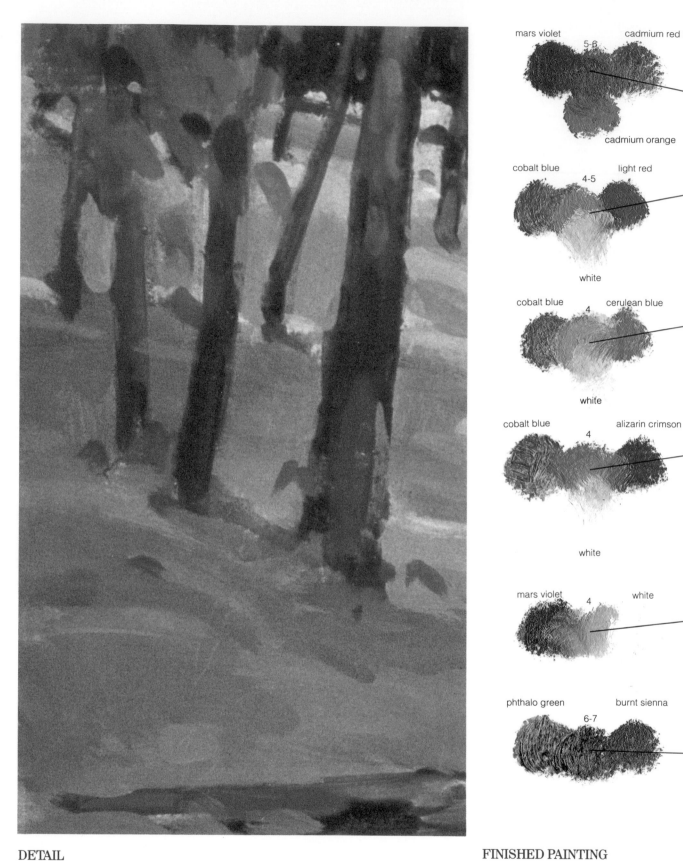

mars violet 5-6 cadmium red light

cadmium orange

cobalt blue 4-5 light red

white

cobalt blue 4 cerulean blue

white

cobalt blue 4 alizarin crimson

white

mars violet 4 white

phthalo green 6-7 burnt sienna

DETAIL
As the dark clump of trees meets the snow, I tried not to cut them off too abruptly. I did this by showing the snow behind the first few trees. This creates a feeling of depth, so that the viewers feel as if they could walk into the painting.

FINISHED PAINTING
Looking out from a darkly wooded place along a stream into a sunny clearing makes for a pleasing contrast. Compositionally, this arrangement creates a focal point in the center of the painting.

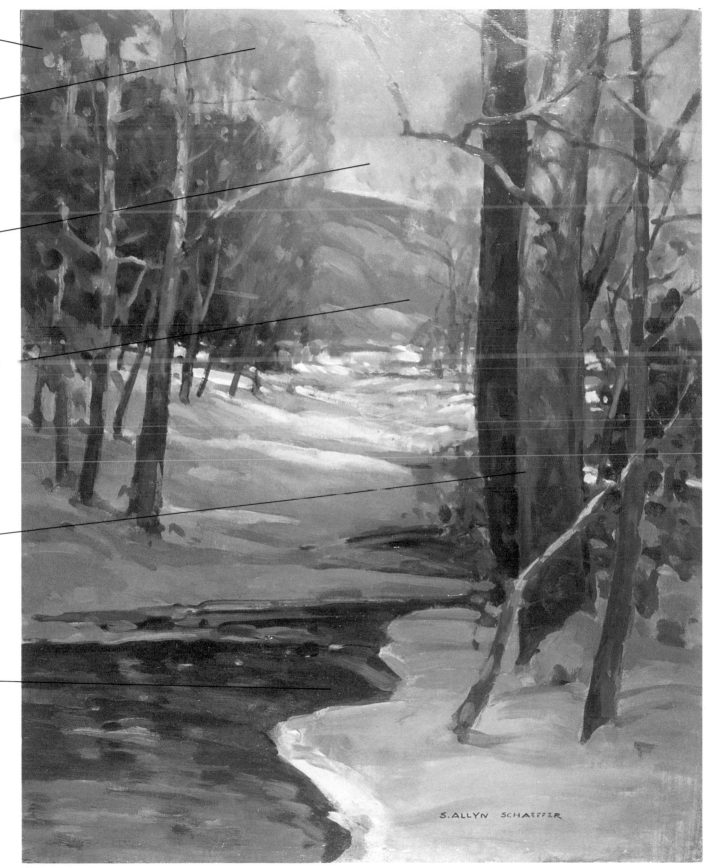

VARIATION No. 3, *oil on panel, 16" × 20" (40.64 × 50.80 cm)*.

Index